IMAGES
of America

BOSNIAN AMERICANS
OF CHICAGOLAND

On the cover: Bosnian and other laborers work on a tunnel near the Lawrence CTA (Chicago Transit Authority) stop in front of Leland Jewelers at 1122 West Leland Avenue, in the uptown neighborhood in the early 1920s. This and other tunnels connected nearby buildings and were reportedly used by Al Capone, fellow mobsters, and speakeasies as an escape route and to transport liquor during the Prohibition era. Under the guidance of fellow Bosnian Arif Dilich, a superintendent for Paschen Construction Company, Bosnian immigrants helped build Chicago. (Courtesy of Muharem Zulfic.)

IMAGES
of America

BOSNIAN AMERICANS
OF CHICAGOLAND

Samira Puskar

ARCADIA
PUBLISHING

Published by Arcadia Publishing
Charleston SC, Chicago IL, Portsmouth NH, San Francisco CA

Printed in the United States of America

Library of Congress Catalog Card Number: 2007924164

For all general information contact Arcadia Publishing at:
Telephone 843-853-2070
Fax 843-853-0044
E-mail sales@arcadiapublishing.com
For customer service and orders:
Toll-Free 1-888-313-2665

Visit us on the Internet at www.arcadiapublishing.com

For my parents, who continue to love, inspire, encourage, and challenge

CONTENTS

ACKNOWLEDGMENTS

I wish to thank the staff members of Arcadia Publishing for their guidance and help on this project. Many others have contributed to this book, and I wish to extend special thanks for their time, participation, and generosity.

The following people have been kind enough to offer images and permission to use them: Nurko Gazija; Muharem Zulfic; Saban and Nefa Torlo; Semsa and Sabid Besic; Rabija Pasabeg; Zerina Zvizdic; Safija Sarich; Mensura Lejlic; Rasema Dedic; Zineta and Meho Kujundzic; Murka Bambur; Mejra and Merim Becirovic; Hasan Avdich; Hajra Karic; Ibrahim and Marija Suljic; Fata and Husnija Suljic; Selena Seferovic; Omer and Fatima Puskar; Semka and Fuad Puskar; Muhamed and Ismeta Puskar; and Mesud Kulauzovic, the Bosnian-American Cultural Association, and the Islamic Cultural Center. I would like to thank Samir Biscevic for his technical help, and Faruk Bogucanin and Muhammad Al-Ahari for their thorough research of the Bosnian American community.

Special thanks to Senad Agic for agreeing to review and edit this book and for offering his advice and expertise, and to my sisters, Sanela and Semka, for their support and encouragement throughout the process.

INTRODUCTION

The story of the first Bosnian Americans is similar to those of their neighbors, having left uncertain times and an agrarian past for the industrial and developing United States. They arrived in the United States a century and a half ago, and many started settling in Chicago roughly 50 years later. Their story of immigration to the United States, like those of many other groups, is about struggle, hard work, and better lives.

There are four major periods of Bosnian and Herzegovinian immigration to the United States. The first was the one that established the Bosnian community in the United States, between the late 19th century and World War I. The second, and less substantial, wave occurred during the interwar period, between 1918 and 1941. The third occurred after World War II and brought more educated and skilled immigrants. The last and likely most significant happened during and after the war in the former Yugoslavia.

As Chicago began to bud in the first part of the 20th century, the first Bosnian Americans began to settle in the city, offering their own big shoulders that literally helped build and establish the city as one of the biggest and best in the country. Mostly young and male, they worked as construction laborers and built city infrastructure, such as tunnels, roads, tracks, and buildings. The city attracted these Bosnians, as both Chicago and the immigrants realized their potential in the new homeland.

The second wave, although small, continued to establish the Bosnian presence in Chicago. These immigrants built the foundation for the religious and social community that would evolve in forthcoming years.

During the post–World War II period, more immigrants than ever had made their way to the shores of Chicago, arriving more educated than previous generations. They also walked in upon a persistently growing city that required both professional and working-class workers, which this wave generously provided.

This wave was also the longest running, having stretched to the start of the Balkan conflict of the 1990s. The fourth wave included refugees from the war, who in time strengthened the Bosnian culture and heritage in Chicago with their presence. While regrettable circumstances required them to leave a cherished homeland, this wave quickly integrated into American society and became established, prosperous, and vital members of the Bosnian American community in both the area and the country.

Bosnians and Herzegovinians hail from their southeast European country, about the size of West Virginia. It is a country of many prominent faiths, where Muslims, the Eastern Orthodox, and Catholics have converged for centuries.

In Chicago, Bosnian Croats would settle among Croatian communities, Bosnian Serbs among Serbian communities, and Bosnian Muslims among their own. But while Bosnian Americans are tied to their ethnicity, they have also been influenced by American society. They have voted, run for public office, engaged in American celebrations, and taken part in the lives of their American friends, neighbors, and colleagues.

While this book offers highlights of Bosnian Americans in Chicagoland, it is limited by both time and format constraints. It is hoped this book will encourage further documenting of the Bosnian community through photographs and the written word for the generations to come. Our Chicago story may be only 100 years young, but it is an inspirational one, and it continues to thrive.

One

FIRST MIGRATIONS

Bosnians and Herzegovinians first came to America by ship, traveling through Europe to reach its ports and embark on visions of prosperity, stability, and religious freedom in the New World. In the era of world fairs and expositions, evidence shows these Bosnian travelers, with their Serbian, Croatian, and other regional counterparts, first visited the United States en masse in the late 19th century to pursue steady work in mines and other industries—all part of a huge wave of European immigration to North America.

Their transitions to Chicago were a result of the emerging trades and need for labor. As leaders planned parks, public transportation, public works projects, and other infrastructure after the Great Chicago Fire of 1871, Bosnians and immigrants of other various ethnic backgrounds helped to make Chicago one of the world's most influential cities by the 1890s.

Many of those who immigrated to Chicago were young, single, and male, with the goal of earning some money and returning to Bosnia to establish a home and family there. Those who stayed would remain single or intermarry with other ethnic groups.

Bosnians of Serbian and Croatian ethnicity settled in the budding immigrant neighborhoods on the South Side of Chicago, migrating toward people with similar Orthodox and Catholic backgrounds. The Eastern Orthodox populations built Holy Resurrection Church near the city's West Side in 1905, and Croatian Catholic groups built a number of parishes on the city's South Side in the second decade of the 20th century.

Like their Slavic brethren, Bosnian Muslims, or Bosniaks, also found a community in a religious setting. Dzemijetul Hajrije, or the Benevolent Society, was formed in 1906 and has, for the last century, served as the foundation for the Bosnian Muslim community in Chicagoland. It was the first Muslim organization in Illinois and possibly the first nationwide.

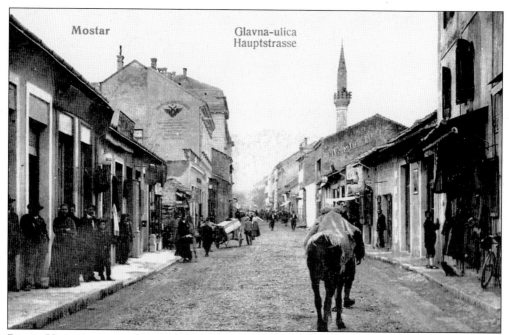

Mostar

Glavna-ulica
Hauptstrasse

Bosnia-Herzegovina, as the immigrants left it, was a simple, agrarian country with a complex, tumultuous political history. This early-20th-century postcard shows the homeland of yesteryear, highlighting the main street of Mostar in southeast Bosnia-Herzegovina. Mostar derives its name from its famous bridge, or *most*, which was destroyed during and rebuilt after the Bosnian war in the 1990s. Pictured here are townsfolk and, in the distance, the minaret of a Mostar mosque.

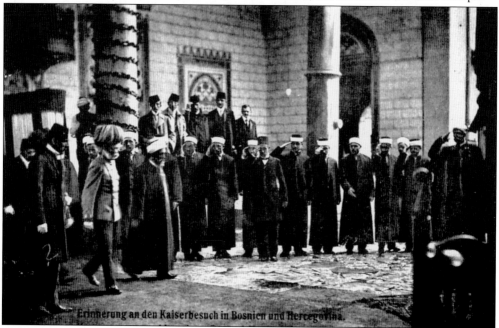

Erinnerung an den Kaiserbesuch in Bosnien und Hercegovina.

Kaiser Franz Josef von Habsburg-Lothringen of Austria walks through a mosque as imams, or *efendije*, salute him during his visit to Bosnia-Herzegovina in 1910. The postcard shows the traditional style of the imam's robe and headdress, which has carried on to this day.

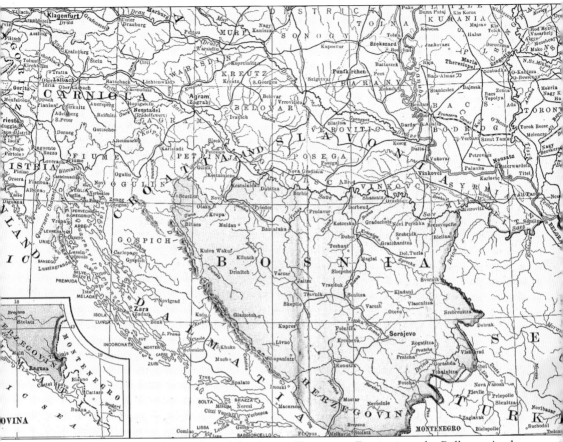

A map from 1899 shows the reaches of the Austro-Hungarian Empire into the Balkans. At the time, Bosnia-Herzegovina was still undergoing the transition from Ottoman to Austro-Hungarian rule; Bosnians of Serb, Croat, and Muslim backgrounds began forming modern-style political parties in response to political changes resulting from the change of rule. The Austrian part of the dual monarchy with Hungary had administrative control over the Balkans. Four years later, in 1914, the kaiser's nephew and heir to the throne, Archduke Franz Ferdinand, was assassinated in Sarajevo, prompting Austria-Hungary's declaration of war against Serbia, and thus World War I. Bosnians in Chicago during this period would hear of changes and developments through newspapers and letters from family back home.

Ulfeta and Mustafa Sarich traveled by boat to America in 1906. They were among the first Bosnians to settle in Chicago in the early 20th century. By 1918, the couple opened a café, known as the Sarich kafana, at 1637 North Clybourn Avenue, in what has become Chicago's Lincoln Park neighborhood. It became a refuge for fellow Bosnians and a place where they could share news and talk about their lives in the New World. (Courtesy of Zerina Zvizdic.)

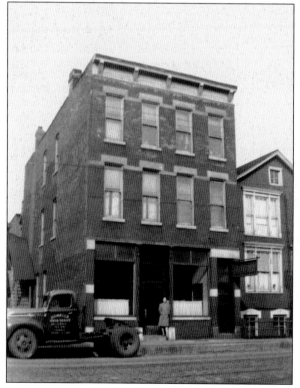

The café where immigrants would meet was in a three-story brick building; the two upper floors were used as a boardinghouse for Bosnian bachelors. Mustafa Sarich worked as Dzemijetul Hajrije's secretary from this building. (Courtesy of Zerina Zvizdic.)

Bosnian American Arif Dilich immigrated to Chicago in 1906 and later served as a superintendent for the Paschen Construction Company, one of Chicago's oldest and largest companies at the time. He had enlisted Bosnian workers for many public works projects. Some men passed down stories that to be hired, they would have their arm muscles checked for strength, were asked to bring a pickax and a shovel, and would push wet cement in a wheelbarrow as a test of their abilities. (Courtesy of Zerina Zvizdic.)

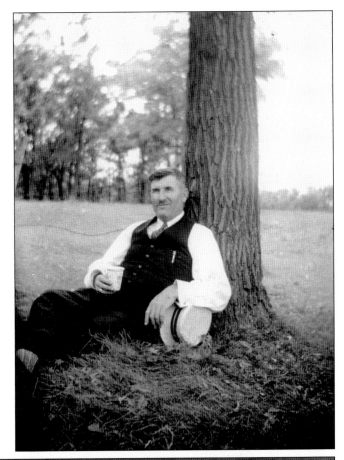

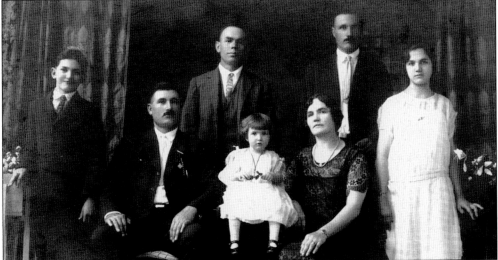

Arif Dilich, a native of Gacko, Bosnia, poses with his wife, Anna, and their children. Dilich was known as a wealthy and generous man; he would invite Bosnian laborers to his farm in rural Woodstock for Independence Day picnics and gatherings. He and Mustafa Sarich were colleagues and friends. (Courtesy of Zerina Zvizdic.)

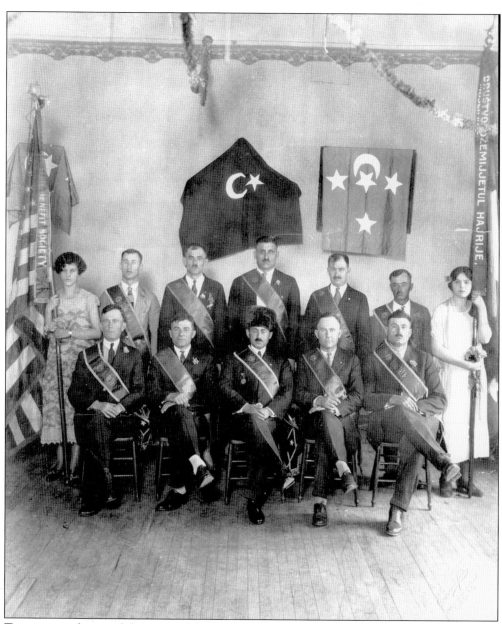

Trustees, members, and the imam of the Dzemijetul Hajrije pose for a group photograph in 1923. The sashes they wear in the picture indicate which position they held in the organization; the man shown in the upper left was the group's imam, and the men in front were trustees. Pictured are, from left to right, (first row) Ramo Vilic, Omer Avdic, Dr. Fuad Hasan Saric, unidentified, and Arif Dilich; (second row) Francis Spahovic, Ramadan Zeky, Meho Jaganjac, Sulejman Nurkovic, unidentified, unidentified, and Helen Dilich. The men are also seen wearing the group's ceremonial badges and pins, and the man in the middle of the front row is wearing a traditional *shubara*, or fur cap. The flags resemble that of Bosnia prior to October 1908, when the Austro-Hungarian Empire formally announced its annexation of Bosnia-Herzegovina after 30 years of administering, and occupying, the land. That move ignited a diplomatic crisis, which touched on the possibility of war, but it ended without conflict. (Courtesy of Muharem Zulfic.)

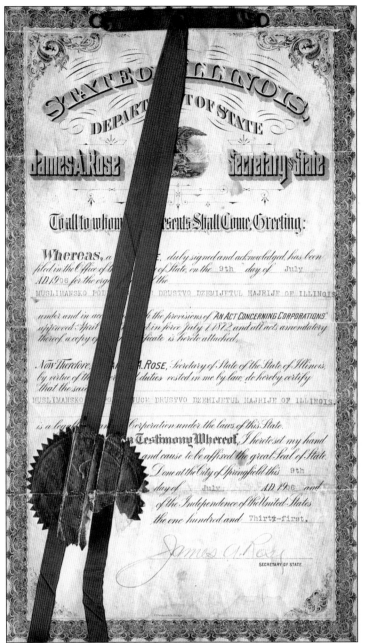

The charter of the Muslim benevolent society Dzemijetul Hajrije represents the beginning of the century-old Bosnian Muslim community in Chicago. Established on July 9, 1906, the organization functioned as a family to many of the single male immigrants, and it provided health care coverage, funerary benefits, and religious services. It also organized celebrations to mark the Eid, or Bajram, holidays. The society provided the essentials to new Americans. However, membership declined over the years with fewer Bosnian migrations and ceased altogether by the 1960s, but its legacy has survived and it has served as the foundation for the present-day Islamic Cultural Center (ICC) in Northbrook. (Courtesy of the Bosnian-American Cultural Association.)

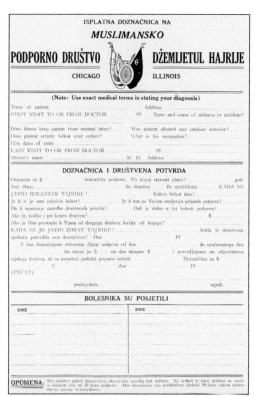

A medical expense reimbursement form was instrumental in helping early members cover the costs of health care and illness; it was an important aspect of membership to the Dzemijetul Hajrije. Members would visit a doctor who was associated with the organization. (Courtesy of Muharem Zulfic.)

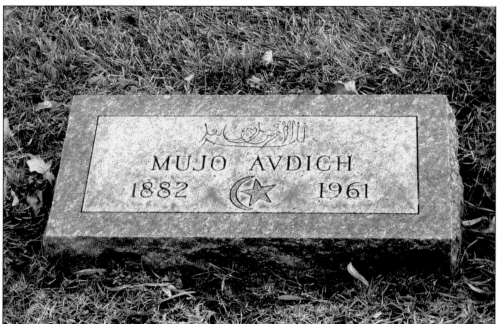

Gravestones of early Bosnian immigrants are placed in the Memorial Park Cemetery in Skokie. According to Ellis Island records, Mujo Avdich emigrated from Plana in southeast Bosnia-Herzegovina in 1907, at 24 years old, on the Italian ship *Giulia*. He was the first among many of the Avdich family to settle in the United States. (Courtesy of Samir Biscevic.)

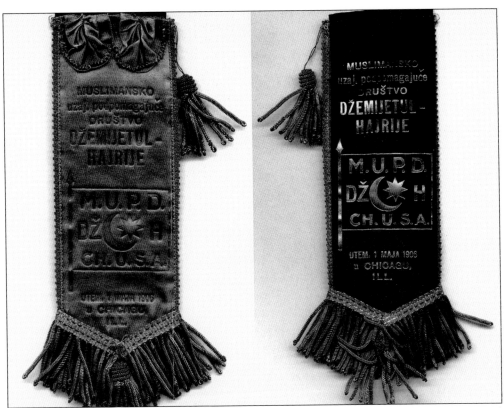

Early members wore badges for community events—green on one side, for celebrations and member activities; and black on the other, for funerals. (Courtesy of Muharem Zulfic.)

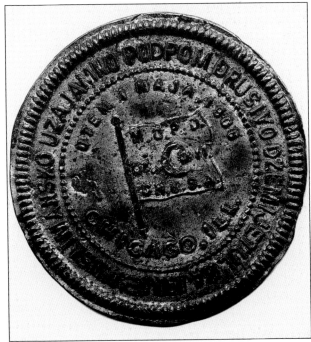

The seal of the Dzemijetul Hajrije organization was used for official purposes. In addition to religious services and celebrations, the organization ensured that members would receive a proper Muslim burial. (Courtesy of Muharem Zulfic.)

The *Titanic* transported four Bosnians en route to America. The passengers, hailing from northwest Bosnia, had third-class cabins. As the story goes, the *Titanic* sank after hitting an iceberg in North Atlantic waters in 1912, bringing the immigrants down with it. They were reportedly trying to reach Harrisburg, Pennsylvania, in search of a small Bosnian community and a steady amount of work in the mines.

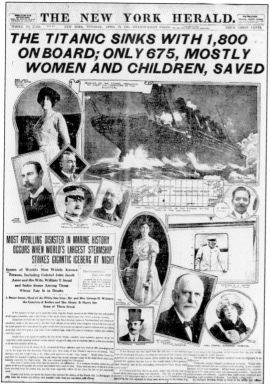

Dated April 16, 1912, the *New York Herald*'s headline displays the news about the *Titanic*'s sinking the day before.

Alija Dizdarevic's registration card for the armed forces is dated June 1917, toward the end of World War I. According to some records, he emigrated from Vitina, Bosnia, via Hamburg, Germany, in April 1907 at age 24. (Courtesy of the Bosnian-American Cultural Association.)

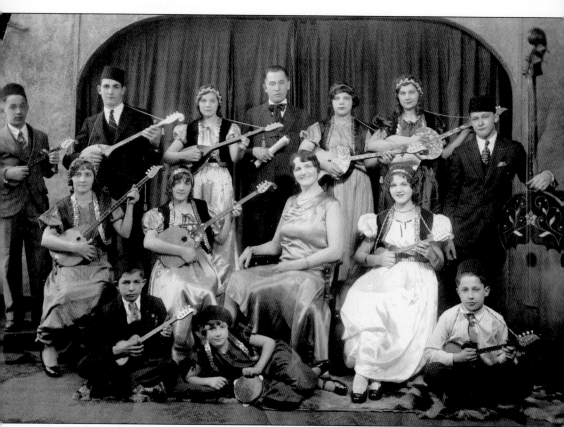

The Bosnian Tamburica music group was established in 1934 by Anna Dilich, wife of Chicago businessman Arif Dilich. With the growth of the Bosnian community, the group contributed to and played a role in organizing cultural events. Here ladies of the group are dressed in traditional folk costumes, and the boys are wearing fez caps. While the Tamburica group no longer exists, similar ones serve the same function today. (Courtesy of Muharem Zulfic.)

Two

THE INTERWAR PERIOD

Between the world wars, from 1918 to 1941, many Bosnians continued to make their way to Chicago and elsewhere in the United States. At the time, in 1918, Bosnia had become an administrative unit in the Kingdom of Serbs, Croats, and Slovenes, which later became Yugoslavia in 1929, under the rule of Karadjordjevic royal family.

This period of the "first Yugoslavia" left Bosnia in a difficult situation. With the shifts in power and uncertain times ahead, thousands of Bosnians and other southeast Europeans made their way to new lands. Agricultural reforms and an economic depression left farmers and Bosnia's largely agrarian economy struggling.

In the United States in the meantime, immigrants' lower wages had a negative effect among American citizens, putting pressure on the U.S. government to close its borders. As a result, the flow of Bosnians and their European neighbors was curtailed with the Quota Act of 1921, which limited immigration to the United States. In 1924, Congress passed the Immigration Act, which allowed only a small percentage of immigrants from a particular nation based on their U.S. population from the 1890 census.

Those who made their way to the United States were similar to their earlier counterparts in that they were mostly single, uneducated laborers in search of better opportunities in this growing land and budding city.

Chicago continued to develop during these years, witnessing large industrial growth and an increase in population, a rising cityscape, and international recognition from the world's fair of 1933.

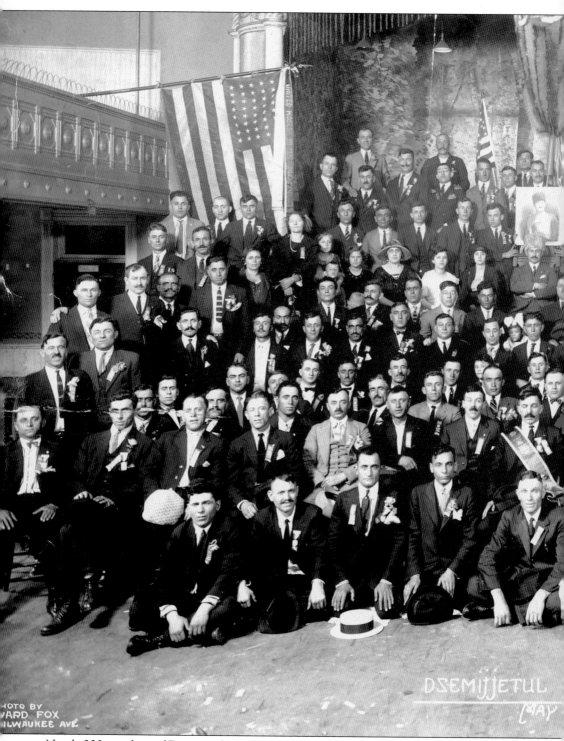

Nearly 200 members of Dzemijetul Hajrije gather for a group portrait on Tuesday, May 22, 1923. A week before, the Eid ul-Fitr holiday took place, which they likely gathered for and celebrated.

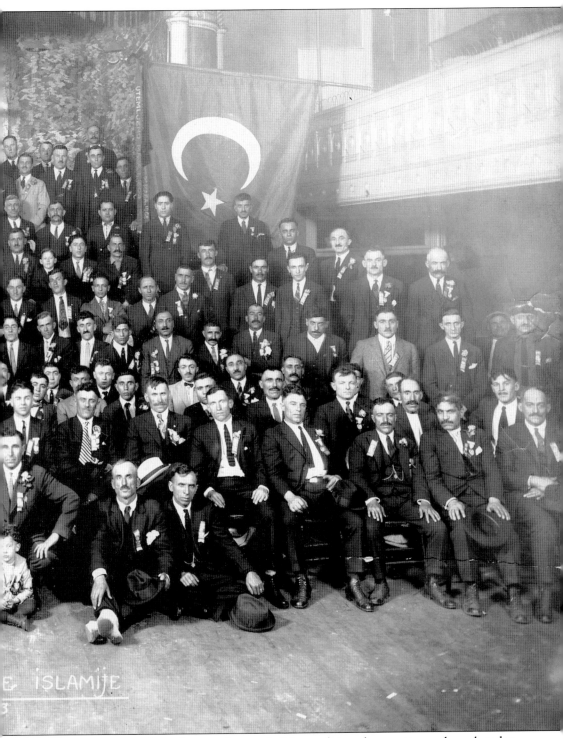

They are seen wearing flower boutonnieres, a holiday tradition that continues through today, and the organization's badges and medals. (Courtesy of Muharem Zulfic.)

Bosnians gather for an undated photograph in Twin Falls, Idaho, where a few immigrated in the early 19th century, some via Chicago. During that time, agriculture became a mainstay of the economy after irrigation canals were built. Twin Falls is now home to present-day Bosnians who settled there during and after the war of the 1990s. (Courtesy of Zerina Zvizdic.)

The town of Butte, Montana, attracted many immigrant workers, Bosnians and Herzegovinians among them, with its ranches and expansive copper, gold, and silver mines. In 1916, they organized a chapter of the Dzemijetul Hajrije to serve the population, which likely never numbered more than 50 people, many of whom lived hundreds of miles from Butte. Bosnians in these parts had connections to those in Chicago, and some eventually moved back to the Midwest. (Courtesy of Muharem Zulfic.)

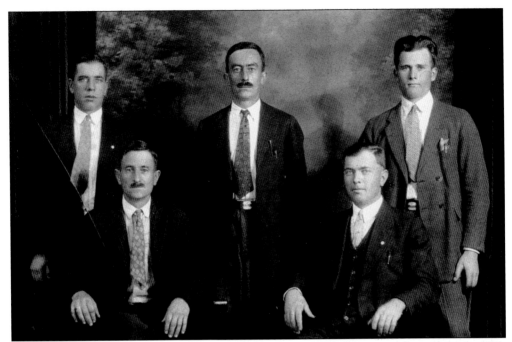

A group of Dzemijetul Hajrije members wearing their membership pins pose for a picture in 1920. The organization witnessed declining growth through the interwar period, given the restrictive immigration laws, and ultimately ceased by the 1960s. However, the organization still exists today as the foundation for the ICC in the northern suburbs. (Courtesy of Zerina Zvizdic.)

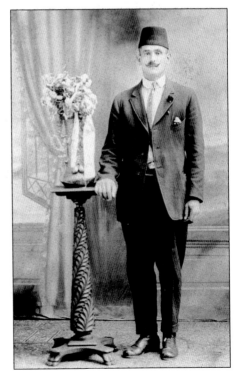

Muhamed Jaganjac immigrated to Chicago from Okoliste in March 1907 with two relatives, one of whom went on to establish the Bosnian community in Montana. Here Jaganjac stands wearing a fez cap and a fancy moustache, common among Bosnian Muslim men at the time. (Courtesy of Zerina Zvizdic.)

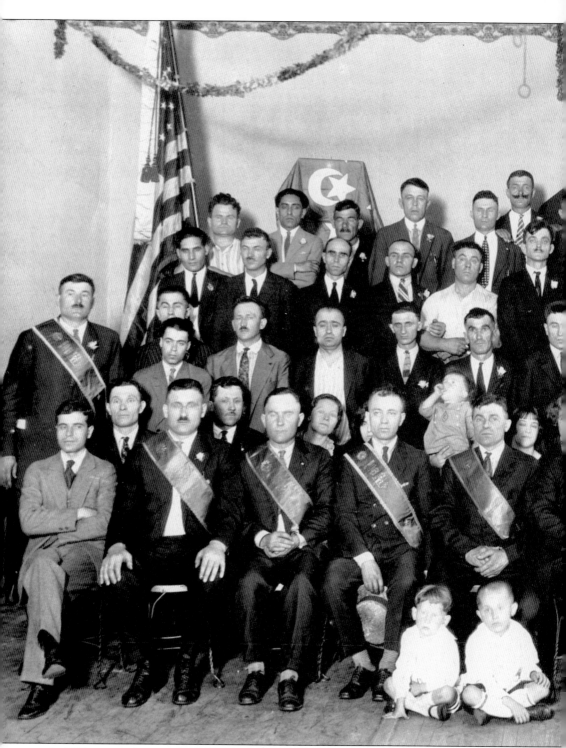

A 1925 group photograph shows about 75 Dzemijetul Hajrije members likely gathering for an Eid celebration. While the number of people in the picture is not reflective of the stricter immigration laws that went into effect earlier that decade, fewer immigrants than usual from

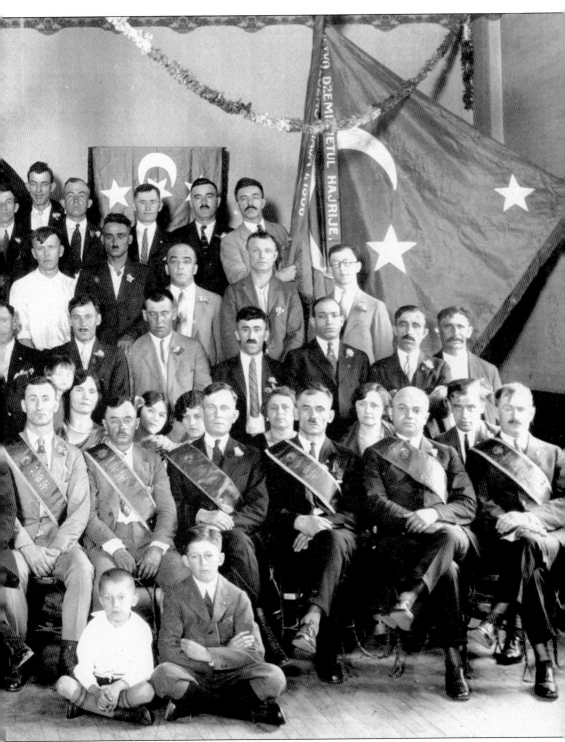

Bosnia and Herzegovina made their way to the United States. After World War I ended in 1918, the numbers dropped sharply. (Courtesy of Muharem Zulfic.)

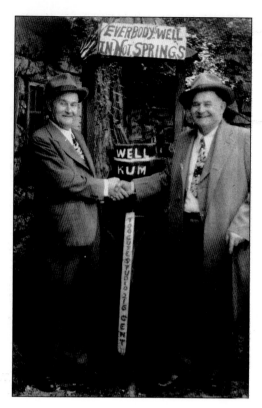

Osman Catovic poses for a novelty photograph. He first arrived in 1905 and helped establish the Dzemijetul Hajrije and in 1913 became one of the founding members and vice president of the Gary, Indiana, chapter. The Gary chapter had 31 members at its start and met at a local boardinghouse. (Courtesy of Zerina Zvizdic.)

Ibro Ovcina arrived to the United States in 1906 and eventually became part of the Bosnian community in Butte, Montana, before returning to his adopted hometown of Chicago, where he passed away in 1969 and is buried in the Bosnian section of the Memorial Park Cemetery in Skokie. (Courtesy of Zerina Zvizdic.)

Adem Dzankovic arrived to Chicago in 1913 when he was in his early 20s. (Courtesy of Zerina Zvizdic.)

At 25 years old, Nezir Krvavac arrived in 1907 on a visit to his friend Sabit Jaganjac in Chicago. Krvavac later moved to Butte, Montana, an even farther cry from his first home of Gracanica in northeast Bosnia. (Courtesy of Zerina Zvizdic.)

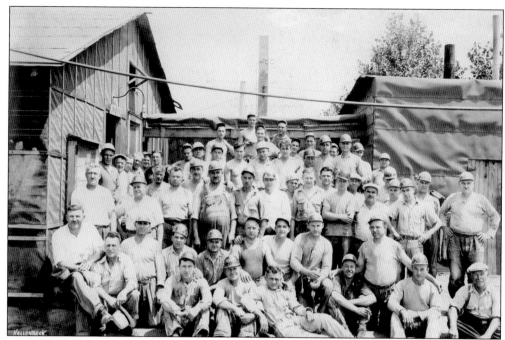

Arif Dilich, seated bottom left, takes a photograph with 50 or so of his fellow Bosnian American workers, employed by the Paschen Construction Company, in 1923. (Courtesy of the Bosnian-American Cultural Association.)

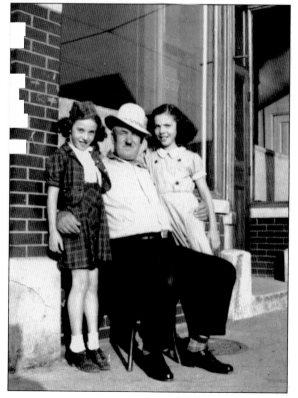

Jusuf Hebib smiles outside the Sarich café with Zerina and Safija Sarich in the late 1930s or early 1940s. Hebib made the Sarich family his own as Chicago became his home. (Courtesy of Zerina Zvizdic.)

Ulfeta Sarich established the Bosnian Women Singers Club in the early 1930s. Women like Sarich helped bring the community together through events and activities that featured the talents of young Bosnians. Through this group and Anna Dilich's Tamburica group, a third women's group, the Kolo Djevojka, or girls' dance club, was organized. Organizations like these helped to keep Bosnian traditions alive. (Courtesy of Muharem Zulfic.)

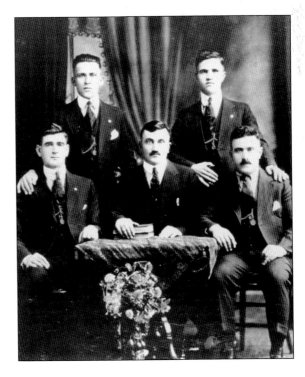

Dzemijetul Hajrije members pose for a photograph in 1934. They are, from left to right, (first row) Maso Hairlic, Adem Dzankovic, and Sulejman Karaica; (second row) Avdo Bajgoric and Meho Premilovic. Chicago at the time was in its second and last season of its world's fair, organized to celebrate Chicago's centennial. (Courtesy of Muharem Zulfic.)

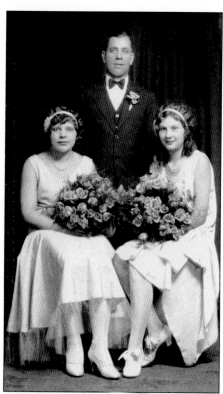

A traditional Bosnian wedding with touches of American style is celebrated here. Hasan Sarich, Mustafa Sarich's brother, arrived in Chicago in 1923 at 27 years old. Here he poses with members of a wedding party. (Courtesy of Zerina Zvizdic.)

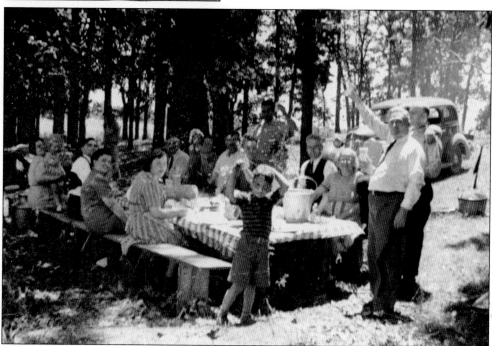

Picnics at the Dilich farm in rural Woodstock, near the Wisconsin-Illinois border, were popular among Bosnians in Chicago. Here they would gather to get away from the bustle of the city and enjoy little reminders of the natural scenery of homeland Bosnia. (Courtesy of Zerina Zvizdic.)

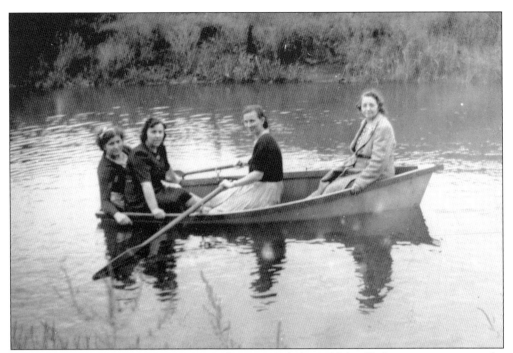

From left to right, Mrs. Max, Anna Sarich, Anna Dilich, and Mrs. Krehic go canoeing on the pond at the Dilich farm. Children would explore the riches of farm life as friends and families would reconnect and share news and stories. (Courtesy of Zerina Zvizdic.)

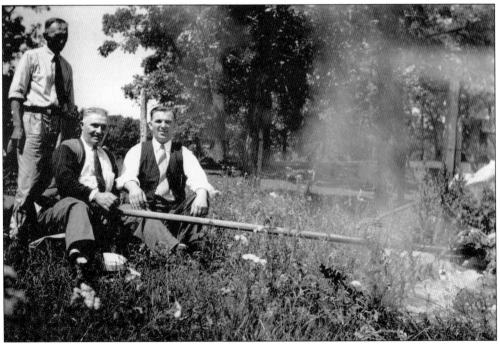

Arif Dilich is seen here roasting a lamb in traditional measure as part of an Independence Day picnic. The custom continues to this day whenever large groups of Bosnian family and friends gather for parties and celebrations. (Courtesy of Zerina Zvizdic.)

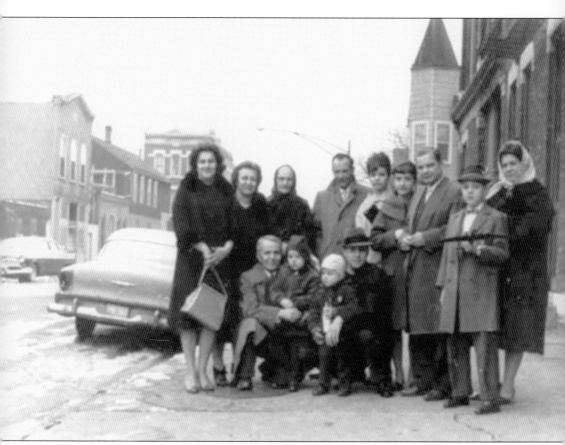

Bosnian Americans gather outside the Muslim Religious and Cultural Home in the 1950s. Members like these were more educated, more involved with the community around them, and more prosperous than their predecessors, due to their schooling in Bosnia-Herzegovina and the surplus of economic opportunity in the United States after World War II. Chicago truly established itself as a cosmopolitan city, replete with jobs and prospects for entrepreneurship. (Courtesy of Rabija Pasabeg.)

Three

THE COLD WAR

World War II and the subsequent Communist leadership under Josip Broz Tito in Yugoslavia served as the impetus for a third wave of Bosnian immigrants to the United States. Faced with mounting religious and political oppression, Bosnians of different faiths and backgrounds took the opportunity to find freedom elsewhere. Air travel was a key reason so many Bosnians moved abroad, as was relaxed travel restrictions in both Yugoslavia and the United States.

Those who established homes in Chicago during this period discovered a growing Bosnian community, one that had grown stronger and more accustomed to American ways and had become organized and defined among other ethnic groups. Some came already educated, as professional businessmen, teachers, and engineers, more so than their predecessors; some came with families. Most of these newcomers arrived with the intention of staying in their new home.

They, with already situated Bosnian Americans, organized the Muslim Religious and Cultural Home, the successor to the Dzemijetul Hajrije of previous decades and the foundation for the later-formed Bosnian-American Cultural Association. In coming years, these immigrants would establish the ICC in Chicago's northern suburb of Northbrook.

Throughout this period, many members of the community set out to form successful businesses in manufacturing industries and to purchase homes and buildings. They were more inclined to pursue higher education or make it possible for their children to do so, and they were also more likely than their predecessors to reach out to and become a more involved part of the world outside their community.

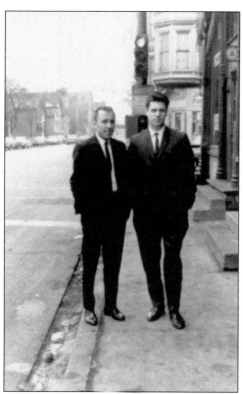

Hasim Hadzialagic (left) and Ilijas Zenkic are pictured outside the Muslim Religious and Cultural Home after it was established on Halsted Street. Hadzialagic and Zenkic are long-standing members of the community and the ICC in Northbrook. (Courtesy of Rabija Pasabeg.)

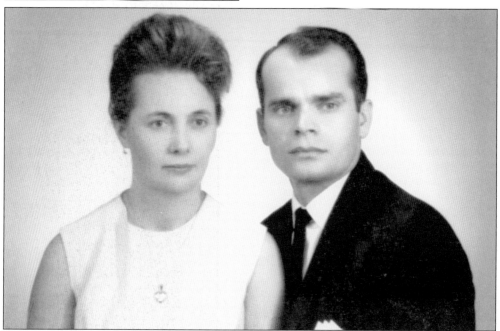

Ibrahim Suljic came to Chicago in May 1960 to escape Communist rule in Yugoslavia. He met Marija during her visit to a friend in Chicago. The couple married in 1964 and has two children, Fadil and Jasna, and five grandchildren. The Suljices were the first of many in their family to settle in the Chicago area. (Courtesy of Ibrahim and Marija Suljic.)

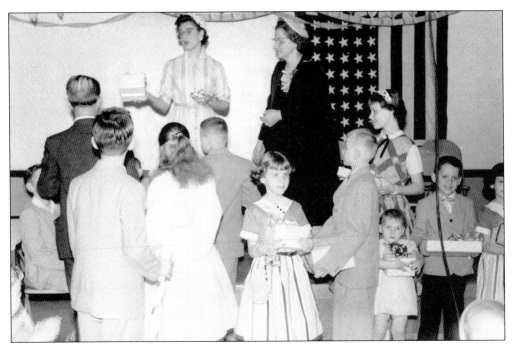

Adila Hairlic, upper left, and Almasa Hairlic, upper right, pass out Eid, or Bajram, presents to children in 1958. Christina Ibragic stands to Almasa Hairlic's left, and Fatima Ibragic, center, holds her gift. Ferid Celik, bottom right, holds his gift as he smiles. The tradition of giving children presents for the holiday continues today. (Courtesy of Zerina Zvizdic.)

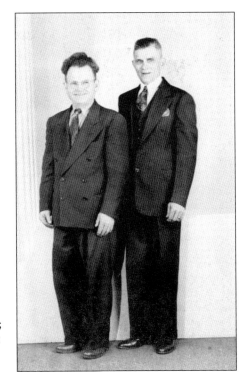

Brothers Nasuf, left, and Jusuf Jaganjac pose for a picture during World War II. According to Ellis Island records, they arrived in Chicago separately; Nasuf immigrated to the United States in 1907 at the age of 19, and Jusuf arrived some years later. (Courtesy of Meho and Zineta Kujundzic.)

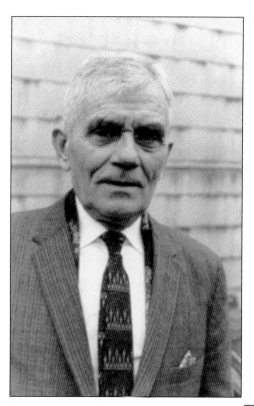

Jusuf Jaganjac came to Chicago in the first wave and was a lifetime member of the Bosnian community in Chicago. He was a laborer by trade, like many of his compatriots. While Jaganjac never learned how to read or write, he was instrumental in helping new Bosnian immigrants get situated in their new hometown, offering guidance in navigating the city, food if one was hungry, and money if one needed a loan. (Courtesy of Rabija Pasabeg.)

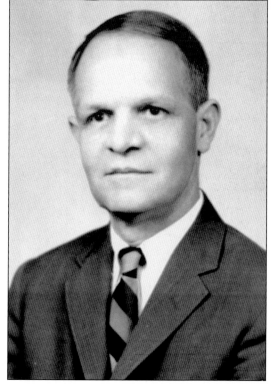

Seid Kadija Karic came to Chicago via Milwaukee when area Bosnian Muslims were looking for a religious leader to head the Muslim Religious and Cultural Home in Chicago, as there was a larger community to serve there. He served as an assistant imam. (Courtesy of Hajra Karic.)

Seid Karic delivers a sermon at the Halsted Street mosque in the 1950s. The mosque was open for nearly 20 years and closed after plans for expansion in a new location began. (Courtesy of Rabija Pasabeg.)

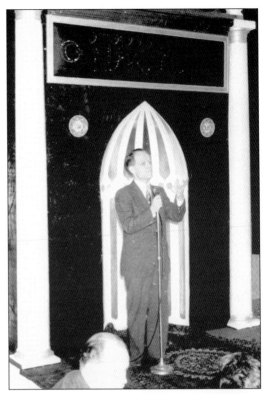

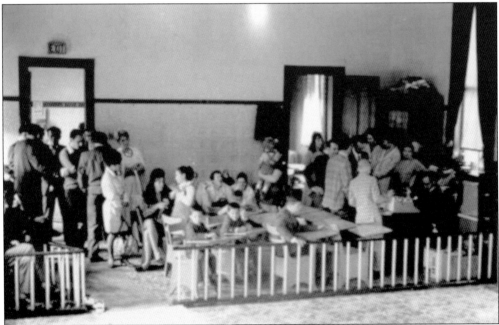

The lower half of the room at the Halsted Street center was used as a social hall for gatherings like the one pictured above. Aside from prayer services and a sense of community, the Muslim Religious and Cultural Home offered Sunday school classes for children and holiday services. (Courtesy of Rabija Pasabeg.)

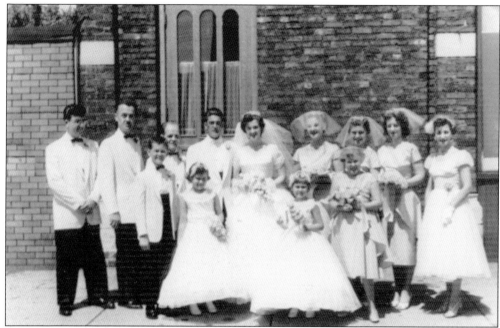

A wedding celebration in 1957 united families. In the picture are, from left to right, Mehmed Hairlic; Mustafa Hasanagic; Dzafer Hairlic; Seid Karic; the groom, Ismet Ablakovic; and the bride, Adila Hairlic, and members of her family. (Courtesy of the Bosnian-American Cultural Association.)

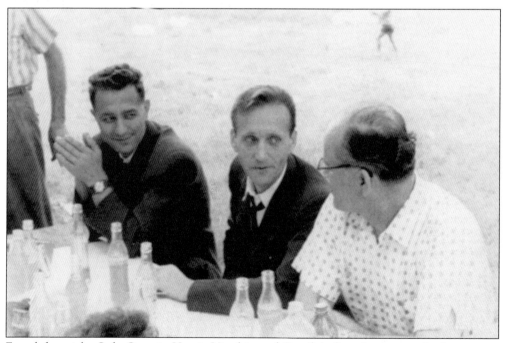

From left to right, Safet Catovic, Husein Viteskic, and Camil Avdic enjoy one another's company at a picnic. Viteskic worked at a Chicago library, Catovic was an agronomist, and Avdic served as the imam for the Bosnian Muslim community for many years and later was elected president of the Bosnian-American Cultural Association. (Courtesy of Hajra Karic.)

Nazif Krvavac was a longtime member of the Bosnian community, arriving in the 1960s. (Courtesy of Meho and Zineta Kujundzic.)

Nurko Gazija was born in Rogatica in eastern Bosnia in 1921. He left Bosnia during World War II and moved to Chicago in 1950 after living in Germany and Austria for a few years. This portrait of Gazija was taken in 1951, a year after he settled in Chicago. (Courtesy of Nurko Gazija.)

Bosnian immigrants developed an image of status among friends and family back home. Pictures they sent home to family would show their life and successes in their new homeland. On visits back home, they would routinely bring gifts and stories about their new life, sharing their adventures and sagas while visiting everyone in the village. Ismet Pasabeg, above, poses with a car in the 1950s. (Courtesy of Rabija Pasabeg.)

Mustafa Gladan, a jeweler by trade, settled in the Chicago area in the 1950s. Here he sits at work at his desk as a watch repairman. In his early years in Chicago, Gladan worked at Goldblatt's Department Store in Chicago. (Courtesy of Rabija Pasabeg.)

Nurko Gazija and his wife, Margaret, pose for a wedding photograph in Salzburg, Austria, in 1952. They later had two children, Ronald and Soraya, and now have five grandchildren. (Courtesy of Nurko Gazija.)

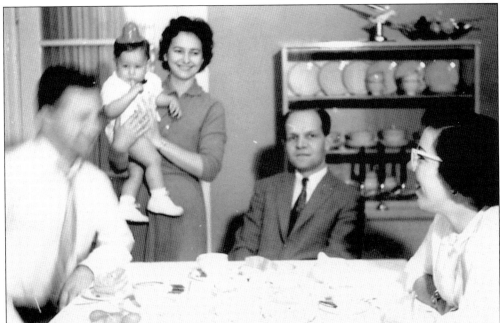

Seid Karic, second from right, lived with the Gazija family for 14 months when he first moved to Chicago for his assignment at the Muslim Religious and Cultural Home. Here he celebrates Soraya Gazija's first birthday in January 1956. Nurko Gazija sits at the left of the table as his wife, Margaret, holds Soraya and Zerina Zvizdic, right, looks on. (Courtesy of Nurko Gazija.)

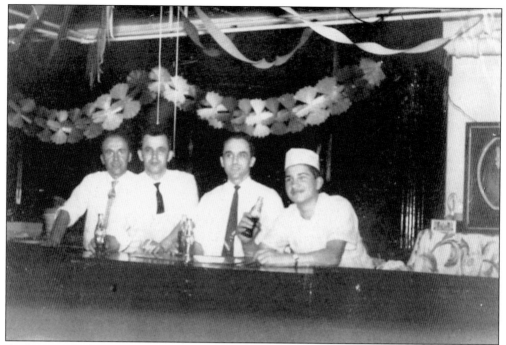

A photograph shows Bosnian Americans enjoying Cokes at a soda counter in April 1958. Standing from left to right are Ramo Lejlic, Zaim Spahic, Meho Kujundzic, and Saban Torlo Jr. (Courtesy of Meho and Zineta Kujundzic.)

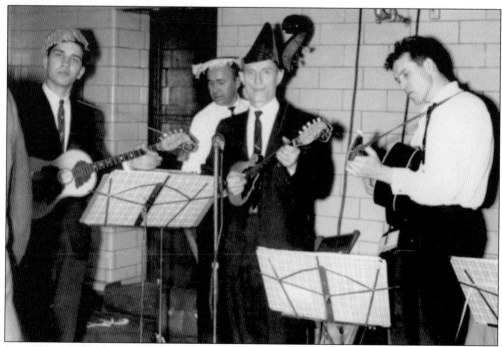

From left to right, Saban Torlo Jr., Ramo Lejlic, Henry Backer, and Mehmed Hairlic play music at an Eid celebration in 1958. (Courtesy of Saban and Nefa Torlo.)

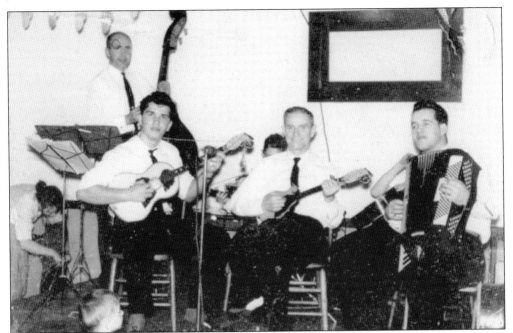

Another group performance brings together, from left to right, Ramo Lejlic on cello, Saban Torlo Jr. on guitar, Henry Backer on guitar, and Mehmed Kisanov on the popular accordion. The band would perform at weddings and religious celebrations. (Courtesy of Saban and Nefa Torlo.)

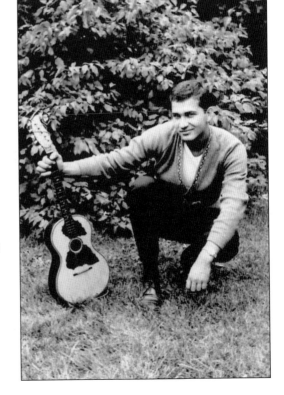

Saban Torlo Jr. poses with his guitar during a community picnic in Chicago in the 1950s. Saban was one of the youngest immigrants of the wave of immigrants who came during and after World War II. He arrived with his mother, Raza, in 1957 at 13 years old; his father, Saban Sr., immigrated to the United States in 1944, shortly after Saban Jr. was born. (Courtesy of Saban and Nefa Torlo.)

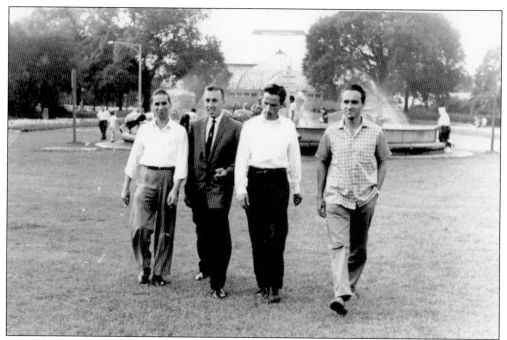

Friends take a stroll through Lincoln Park in the late 1950s. Esef Tulic, Hasim Hadzialagic, Mehmed Alicajic, and Meho Kujundzic, from left to right, have known one another since they arrived from Bosnia-Herzegovina 50 years ago. (Courtesy of Meho and Zineta Kujundzic.)

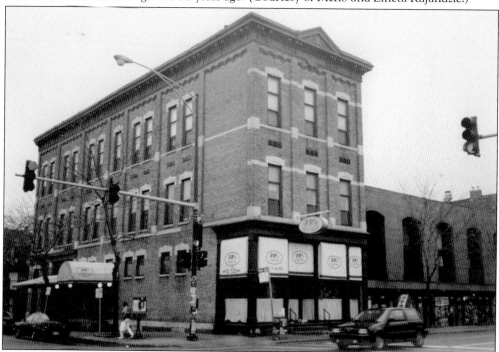

The Muslim Religious and Cultural Home occupied the upper two floors and the basement of this building on the corner of Halsted and Willow Streets in Chicago. A separate restaurant occupied the main floor. (Courtesy of Samir Biscevic.)

A State of Illinois certificate confirms the incorporation of the Muslim Religious and Cultural Home in March 1955. (Courtesy of the Bosnian-American Cultural Association.)

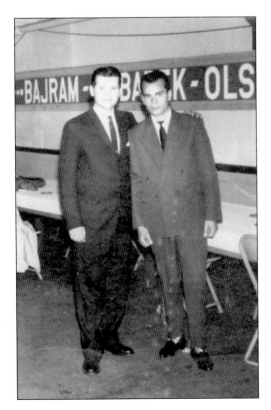

Ibrahim Suljic, right, celebrates Eid with Selim Dervic in 1960. The sign behind the men reads, *Bajram Mubarek Olsun,* translated as "Eid Greetings." (Courtesy of Ibrahim and Marija Suljic.)

A Bosnian group picnic, complete with musical instruments, takes place at a park in Chicago, likely off Foster Avenue. Weekends and holidays provided a chance for Bosnian Americans to gather and reconnect. Joining the picnic, standing from left to right, are Saban Torlo Jr., Remzo Selimovic, Muradif Jesarevic (kneeling), Ramo Lejlic, Henry Backer, Haki Kalaba, Ana Kalaba,

Sofija Selimovic, Kata Jesarevic, Arif Jesarevic, Raza Torlo, Julia Pekovic, Ana Backer, Sefika Bojic, Christina Ibragic, Mehmed Alicajic, Ibrahim Suljic, Jusuf Jaganjac, Ana Jesarevic, and Prof. Mustafa Festic. Kneeling in the center are Emro Pekovic (left) and imam Camil Avdic. Others are not identified. (Courtesy of the Bosnian-American Cultural Association.)

Meho Kujundzic arrived in 1956. He lived in Chicago and worked various industrial jobs when he first settled in the area. (Courtesy of Meho and Zineta Kujundzic.)

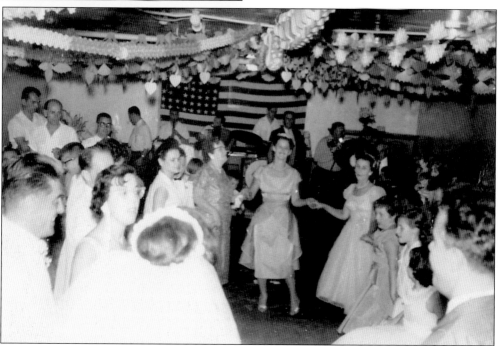

A snapshot is taken of a 1950s wedding, held in the basement of the Muslim Religious and Cultural Home, where women dance the ever-popular *kolo*. In the left foreground, wearing glasses, is Zerina Zvizdic. (Courtesy of Ibrahim and Marija Suljic.)

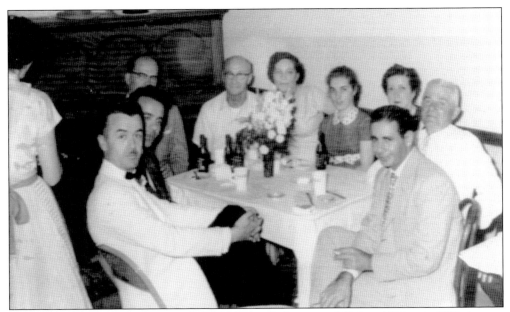

A party takes place in the basement of the Muslim Religious and Cultural Home in 1957. Among the group, from left to right, are Mustafa Hasanagic, Fehim Niksic, Camil Avdic, Ramadan and Mary Zeky, a relative of Ramadan, Olga and Omer Avdic, and an unidentified man. (Courtesy of the Bosnian-American Cultural Association.)

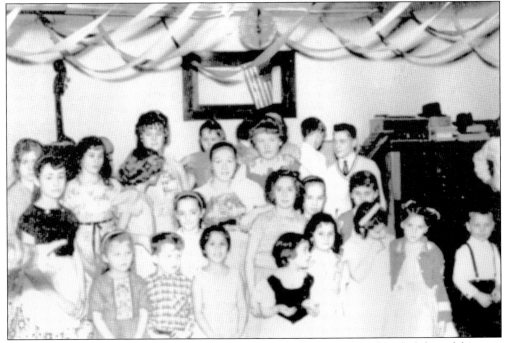

Sunday school students pose for a photograph in 1963 for what looks to be a holiday celebration. (Courtesy of the Bosnian-American Cultural Association.)

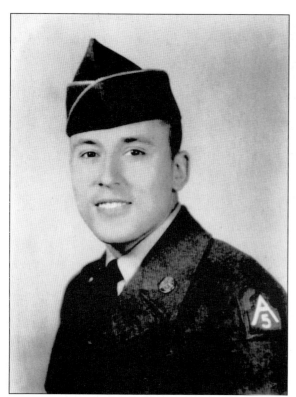

Hasim Hadzialagic joined the American armed forces after moving to the United States in the 1950s. He is one of the oldest members of the Bosnian community in the Chicago area. (Courtesy of the Bosnian-American Cultural Association.)

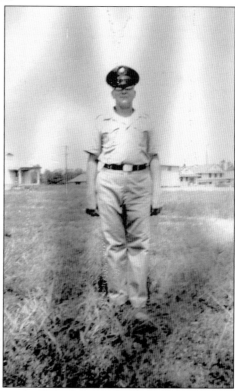

Enver Avdic, Omer Avdic's son, also served in the U.S. military. (Courtesy of the Bosnian-American Cultural Association.)

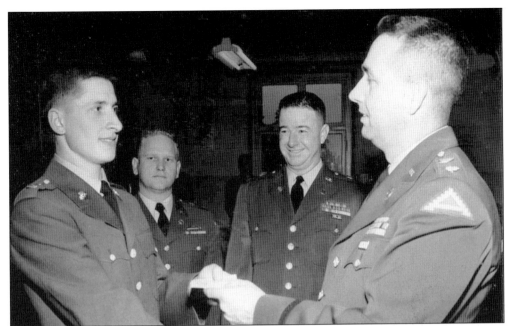

Ismet Pasabeg, above left, joined the army in the 1950s after settling in the United States. Originally from Zenica, he is one of many who left Yugoslavia at the start of the Communist regime in the former Yugoslavia. (Courtesy of Rabija Pasabeg.)

Saban Torlo Jr. poses for his Cooley High School yearbook photograph in 1961. At the start of the Vietnam War, Torlo went to sign up for the draft in downtown Chicago. After selling his car and quitting his job, Torlo joined thousands in line, as he recalls, and was in the half of the line that was sent home. (Courtesy of Saban and Nefa Torlo.)

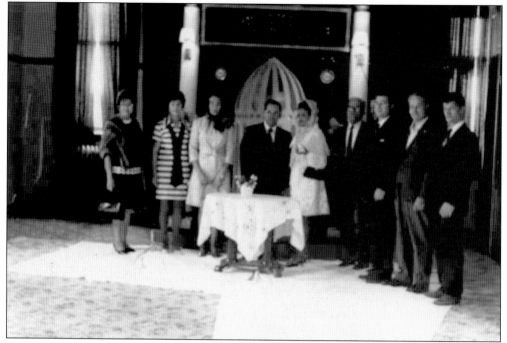

Bosnian marriage ceremonies, like the one from the 1960s pictured above, typically take place in mosques, the venue for most major life events. Nowadays wedding receptions are usually done up American style at a banquet hall. (Courtesy of Rabija Pasabeg.)

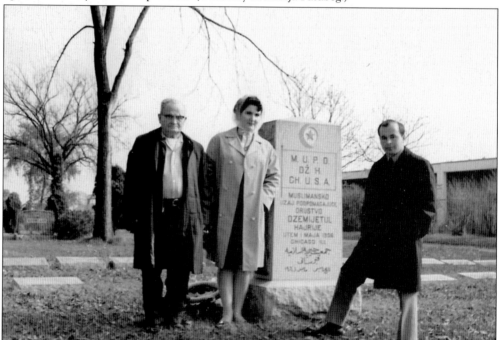

From left to right, Nasuf Jaganjac, Zineta Kujundzic, and Nazif Krvavac pay respects to friends and family at the Memorial Park Cemetery in Skokie in November 1969. (Courtesy of Meho and Zineta Kujundzic.)

54

The seventh annual convention of the Federation of Islamic Associations took place in 1958 at the Islamic Center in Washington, D.C. Pictured here are Muslims gathered for Friday prayer, among them, in the bottom right corner, Omer Avdic and Ramadan Zeky, an Albanian by nationality but a longtime member of the Bosnian Muslim community. (Courtesy of the Bosnian-American Cultural Association.)

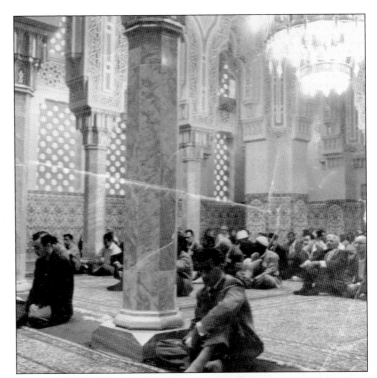

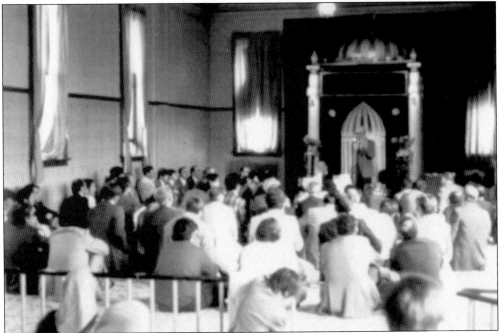

Members of the Muslim Religious and Cultural Home on Halsted Street in Chicago listen to a lecture given by Camil Avdic, who served as the first permanent imam to the city's Bosnian community in the 1960s. The center was opened in 1957 to serve the growing Bosnian-American population. Behind Avdic is the *mihrab*, designed by a member of the center. Its purpose is to show the direction in which to pray toward Mecca. (Courtesy of Rabija Pasabeg.)

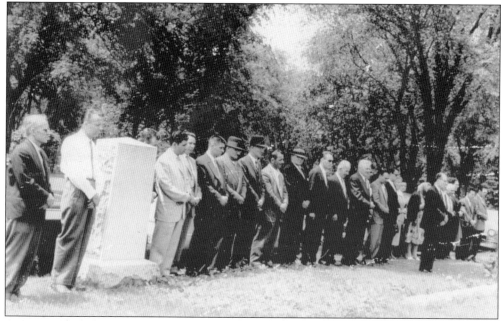

A funeral prayer is held at the Memorial Park Cemetery in Skokie in 1961. It is customary for men to pray at funerals; services are usually held at a funeral home, and preparations of the deceased are done in a traditional religious manner. (Courtesy of the Bosnian-American Cultural Association.)

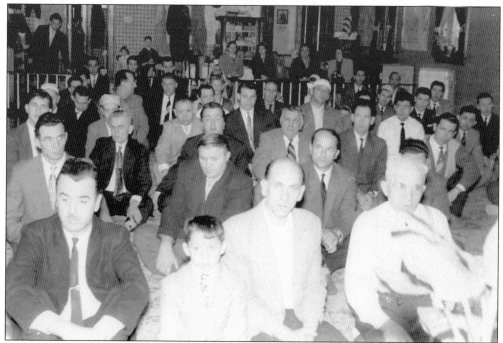

Bosnian men listen to a sermon in the prayer hall at the Muslim Religious and Cultural Home in 1958. A few women listen on from the back portion of the hall. (Courtesy of Saban and Nefa Torlo.)

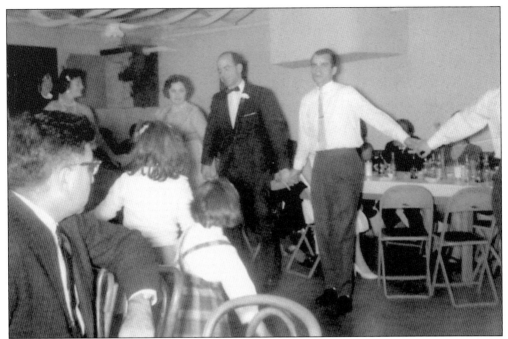

Bosnians love the kolo and will start the dance whenever the opportunity arises and the accordion music is going. They are gathered here in November 1962 for Husein Novkinic's wedding. (Courtesy of Ibrahim and Marija Suljic.)

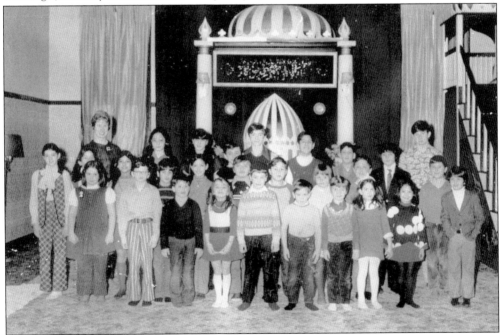

A Sunday school class poses in the prayer hall in the 1960s for a group photograph at the Halsted Street mosque. Children typically attend religious classes from five years old through their teenage years, learning recitations, history, how to pray, and cultural and religious responsibilities. (Courtesy of the Bosnian-American Cultural Association.)

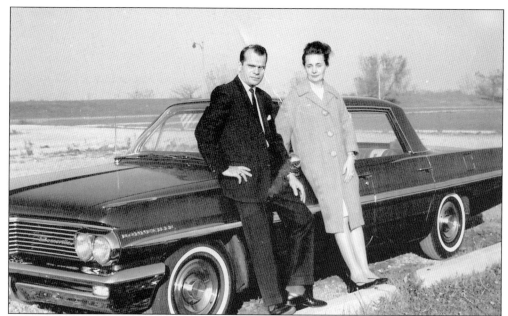

Ibrahim and Marija Suljic pose with their Pontiac Bonneville in 1963 at Calumet Park. The couple first lived in Chicago, in Lincoln Park. Later they moved to Niles. (Courtesy of Ibrahim and Marija Suljic.)

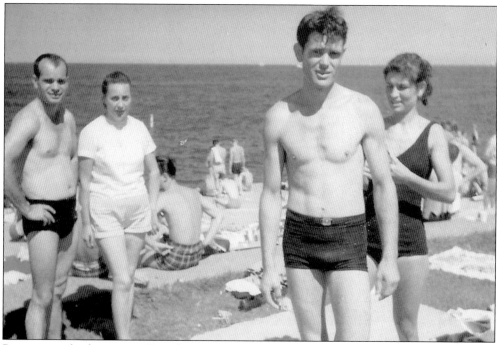

Bosnians and other native Yugoslavs would gather at the beach near Fullerton and Diversey Avenues in Chicago during the weekends of the 1950s and 1960s to socialize, grill food, play soccer, and swim. Here Ibrahim and Marija Suljic, left, enjoy the sunny weather with another couple. Along the lakeside beach, groups of various ethnicities would gather at their regular spots as those from the former Yugoslavia did. (Courtesy of Ibrahim and Marija Suljic.)

Meho Omerbegovic (left), Mustafa Lopardija (center), and Hrusto Ajanovic gather for a quick photograph in Chicago in the 1960s. (Courtesy of Rabija Pasabeg.)

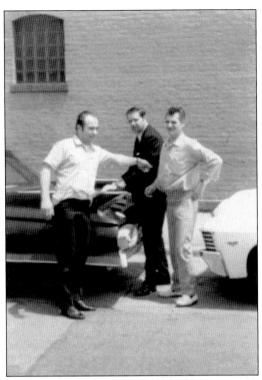

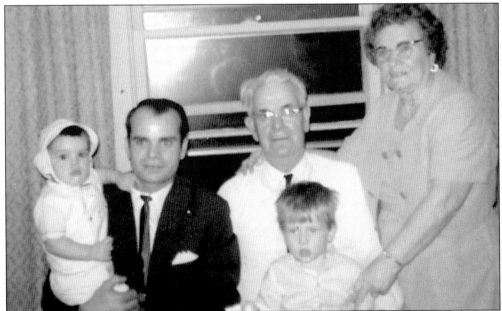

Teta Katy, right, poses with her husband, Salko Mureskic, Salih Alicajic, Ibrahim Suljic, and his son, Fadil, in the 1960s. Teta Katy was known to cook for everyone, and legend has it that if someone was not hungry, she would pack food up for them to eat later. Some well-remembered dishes from Katy include roast lamb, roast chicken, pita, and stuffed peppers. Her husband, Salko, came to Chicago in 1912 from Cazin in Bosnia-Herzegovina. (Courtesy of Ibrahim and Marija Suljic.)

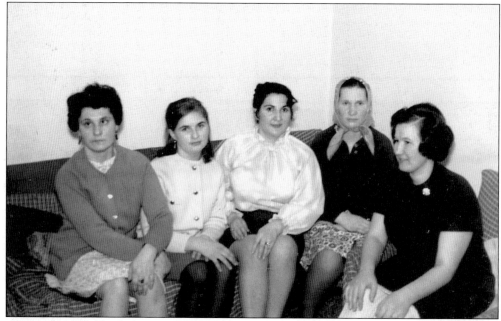

A gathering of friends brings together, from left to right, Abida Bambur, Murka Bambur, Zineta Kujundzic, Zehra Bambur, and Latifa Spahic around 1970. (Courtesy of Meho and Zineta Kujundzic.)

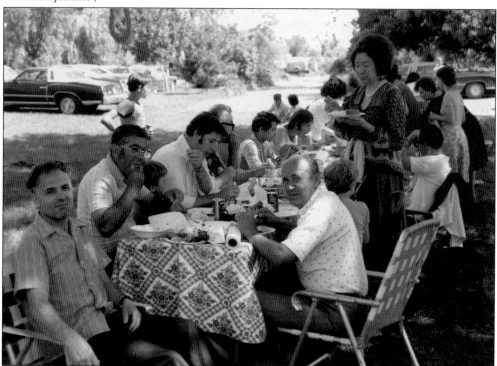

Muharem Zulfic hosts a Fourth of July picnic for the Bosnian community. Ramo Lejlic is seated at the table, right foreground, and his wife, Mensura, stands behind him. Zulfic, wearing his recognizable glasses, is seated at the table behind Mensura. (Courtesy of Mensura Leljic.)

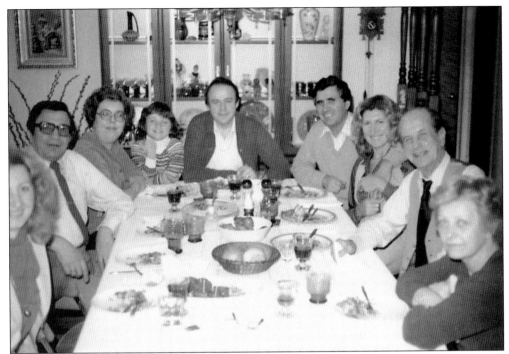

Dinner at the Gazijas in the 1970s brought together members of the community. In this photograph, from left to right, are Branka Gladan, Sukrija Zvizdic, Zerina Zvizdic, Soraya Gazija, Mustafa Gladan, Hasan Avdich, Mira Avdich, Hrusto Salihbegovic, and Margaret Gazija. (Courtesy of Nurko Gazija.)

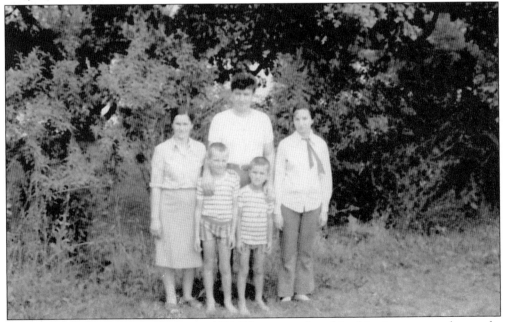

The Besic family moved to Chicago in 1971. They are gathered in this picture a couple months after they first arrived from Bosnia; from left to right are Semsa, Sakib, Sabid, Said, and Saima Besic. (Courtesy of Sabid and Semsa Besic.)

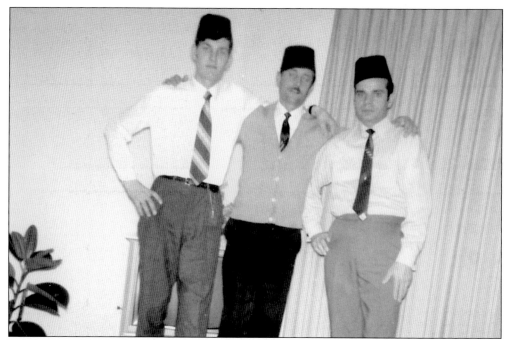

Bosnian men don the fez in homage to their forefathers, who adopted it from eastern influences. Here, from left to right, Feho Redzic, Hase Puskar, and Ibrahim Suljic stand tall for a picture in 1970 during Puskar's first visit to the United States. (Courtesy of Ibrahim and Marija Suljic.)

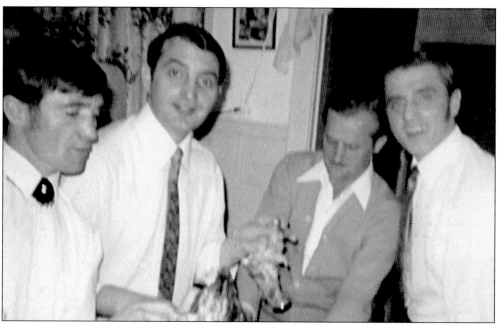

The Puskar brothers, from left to right, Kasim, Asim, Hase, and Halil, feast on a turkey dinner in March 1970. Hase visited his brothers from Cazin, Bosnia-Herzegovina, after they established themselves in America. Omer, the fifth and youngest brother, is not pictured. (Courtesy of Muhamed and Ismeta Puskar.)

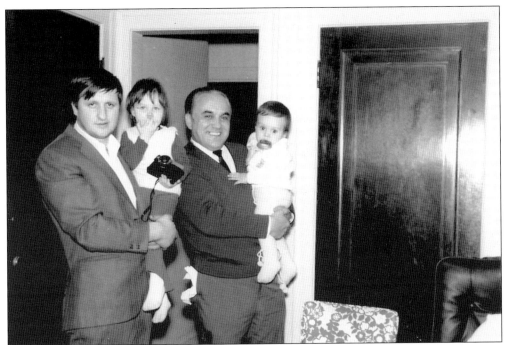

Ekrem Bambur, left, is pictured with his daughter Semka and Meho Kujundzic with his son, Kemal, in 1971. (Courtesy of Meho and Zineta Kujundzic.)

The Suljices pose near a car display in Chicago in August 1972. Standing from left to right are Husnija Suljic; Fadil Suljic; Marija Suljic (Fadil and Jasna's mother); Jasna Suljic; and a family friend, Mehmed Becirovic. (Courtesy of Ibrahim and Marija Suljic.)

Murka and Ekrem Bambur pose with their Pontiac in the 1970s, soon after arriving to the Chicago area from Bosnia. They established themselves in Mount Prospect and had three children, Semka, Samin, and Genana. Ekrem worked in manufacturing and real estate. (Courtesy of Murka Bambur.)

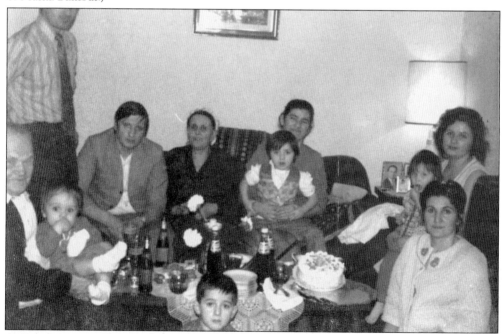

A party brings together, clockwise from the left, Nasuf Jaganjac holding Kemal Kujundzic; Suad Kljako; Ekrem Bambur; Zineta Kujundzic's mother, Gara Kljako holding her daughter, Suvada; Murka Bambur holding her daughter Semka; Zineta Kujundzic; and Miralem Kljako. (Courtesy of Meho and Zineta Kujundzic.)

The shore of Lake Michigan provides a perfect backdrop for a photograph, taken in 1972, of Kemal Kujundzic (left), Nasuf Jaganjac, and Zineta Kujundzic. (Courtesy of Meho and Zineta Kujundzic.)

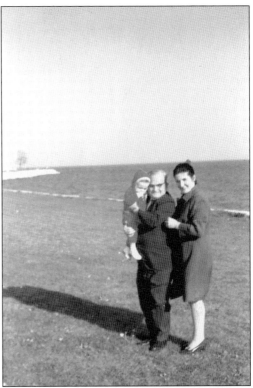

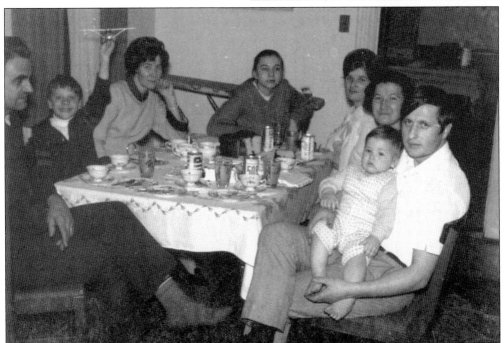

From left to right, Zaim Spahic, unidentified, unidentified, unidentified, Murka Bambur, Latifa Spahic, and Ekrem Bambur, holding baby Sakib Spahic, enjoy the Bosnian tradition of strong espressolike coffee and cake in the 1970s. (Courtesy of Murka Bambur.)

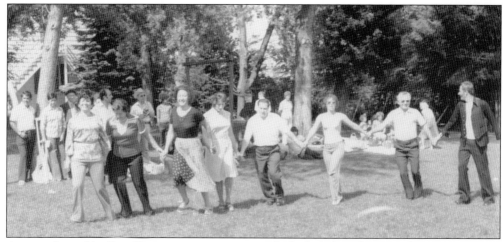

A picnic hosted by Ilijas Rustempasic gets going with the kolo line dance in the 1970s. Among the dancers is Mensura Lejlic, third from left. (Courtesy of Mensura Leljic.)

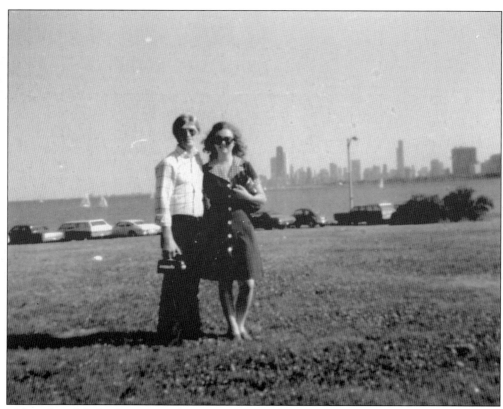

Mehmed and Sofia Becirovic take a snapshot at the edge of Lake Michigan in the 1970s. (Courtesy of Fata and Husnija Suljic.)

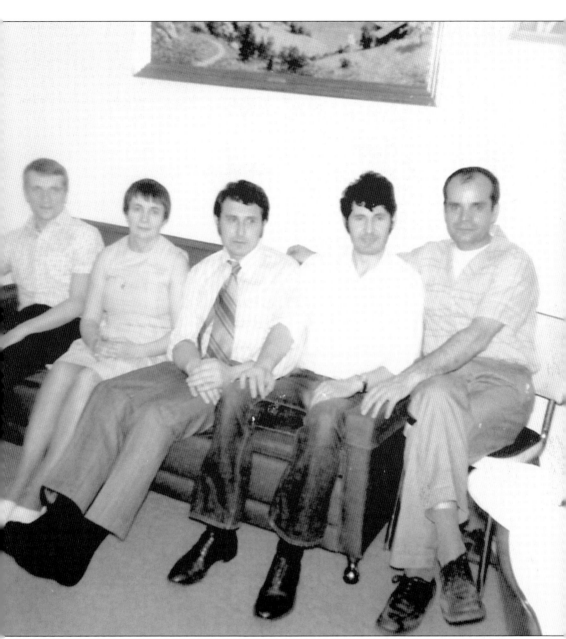

Friends and family gather for a picture in May 1972; from left to right are Husnija Suljic, Marija Suljic, Mesud Kulauzovic, Ibrahim Kulauzovic, and Ibrahim Suljic. (Courtesy of Ibrahim and Marija Suljic.)

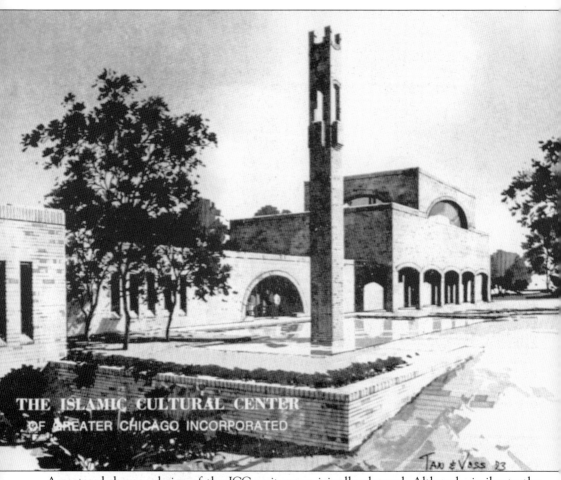

THE ISLAMIC CULTURAL CENTER
OF GREATER CHICAGO INCORPORATED

TAN & VOSS 83

A postcard shows a design of the ICC as it was originally planned. Although similar to the executed design, this plan had a different minaret style and exterior brick pattern. (Courtesy of the Bosnian-American Cultural Association.)

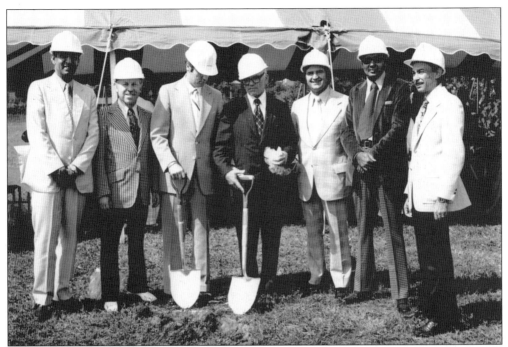

From left to right, Mohsin Qureshi, Hassan el-Khatib, Ilijas Zenkic, Camil Avdic, Ilijas Rustempasic, Afsar Alikhan, and an unidentified man take part in the groundbreaking ceremony for the construction of the ICC in 1974. Avdic was especially instrumental in establishing the new center. (Courtesy of Hasan Avdich)

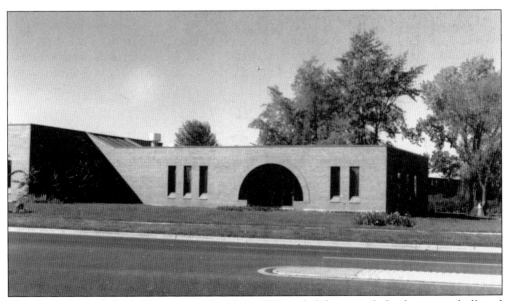

The first phase of the ICC was completed in 1976 and did not include the prayer hall and minaret. It was designed to include classrooms, a small prayer hall, a library, janitor's quarters, administrative offices, and a social hall and large kitchen in the basement. (Courtesy of Muharem Zulfic.)

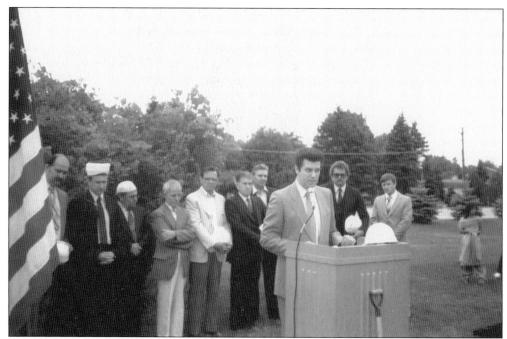

Ilijas Zenkic delivers an address at the grand opening of the ICC in Northbrook in 1983. Lined up behind him, from left to right, are Saban Torlo Jr.; Mustafa Ceric; Rafiq Diab; Seid Karic; Emro Pekovic; Adil Vrtagic; Sabid Besic; an unidentified man; and Ekrem Bambur. (Courtesy of Muharem Zulfic.)

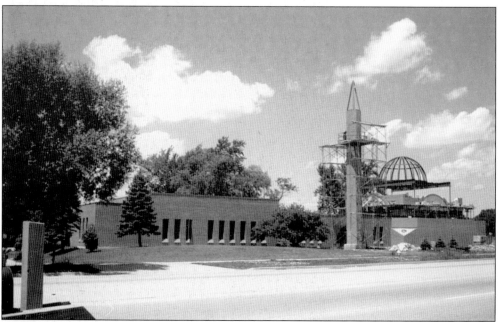

The ICC's second phase of construction was for the minaret and prayer hall on the first floor. The larger space enabled the move of prayer services to a newer, much larger space. Below the prayer hall, a lecture hall was built where educational discourse, speeches, and other events are held. (Courtesy of the Bosnian-American Cultural Association.)

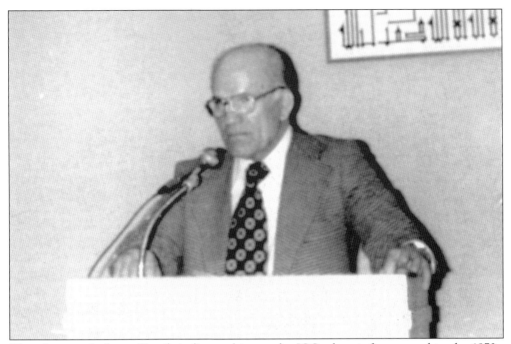

This photograph shows Camil Avdic speaking at the ICC when it first opened in the 1970s. (Courtesy of Rabija Pasabeg.)

Mustafa Ceric served as imam of the ICC after Rafiq Diab, from 1981 to 1986. During his tenure, Ceric developed Arabic- and Bosnian-language religious classes. He also earned a doctorate in Islamic studies from the University of Chicago before heading back to Bosnia to serve as the religious leader of the Muslim community there. (Courtesy of the Bosnian-American Cultural Association.)

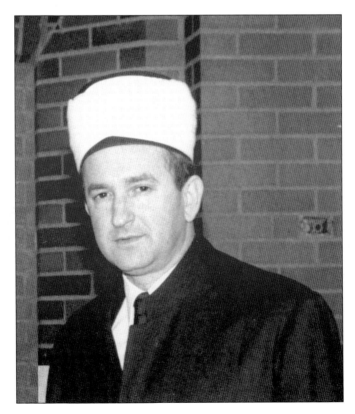

A Sunday school class in 1978 poses for a snapshot on a sunny day. Mensura Lejlic, top center, taught religious classes for many years. Among the children here are, in the front row, Vildana Kujundjic, fourth from left; and Essad Puskar, third from right. Velia Torlo stands in the second row, second from left. (Courtesy of Mensura Lejlic.)

Class is in session in the early 1980s at the ICC. The two boys in the front right are Mehmed Kljako, left, and Velia Torlo. The ICC was designed to include classrooms for Sunday school classes and a quickly growing community, as more families had children and more families were coming over from Bosnia-Herzegovina. (Courtesy of the Bosnian-American Cultural Association.)

An older religion class is held at the same time in the ICC library. Among the Bosnians in the group are Suvada Kljako, foreground; and Rifet and Sakib Spahic, center. (Courtesy of the Bosnian-American Cultural Association.)

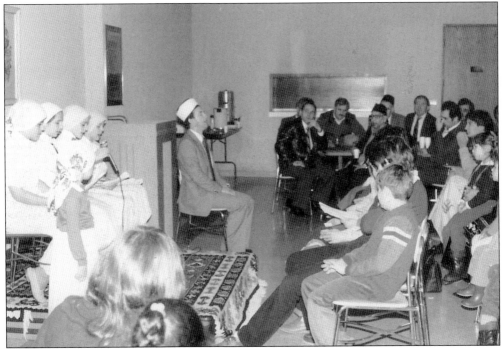

Mustafa Ceric and a group of young girls recite to a crowd in the basement social hall of the ICC in the early 1980s, before the prayer hall was built. (Courtesy of Sabid and Semsa Besic.)

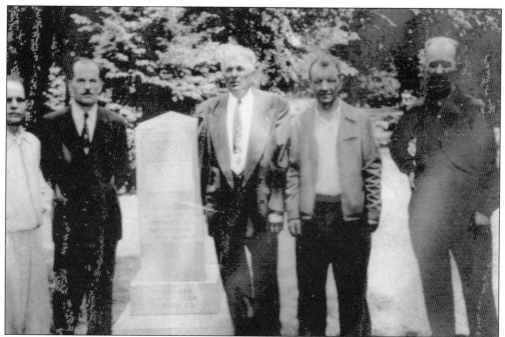

Omer Avdic, center, was the last member of the Dzemijetul Hajrije when he died in 1985 at the age of 95. In the picture he is standing next to a memorial to the Dzemijetul Hajrije, placed near the grave sites of many of the former members. (Courtesy of the Bosnian-American Cultural Association.)

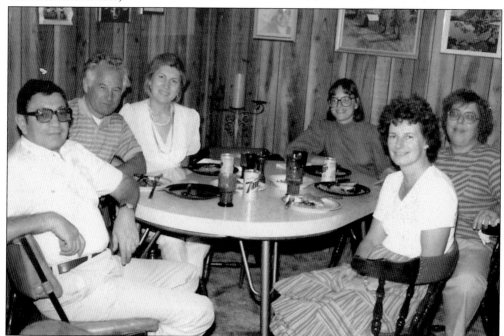

Friends and family gather in Nurko and Margaret Gazija's Chicago basement in 1986 during her sister's visit from Salzburg. Seated from left to right are Sukrija Zvizdic, Nurko Gazija, Mira Avdich, Soraya Gazija, Zerina Zvizdic, and Margaret's sister Sonja. (Courtesy of Nurko Gazija.)

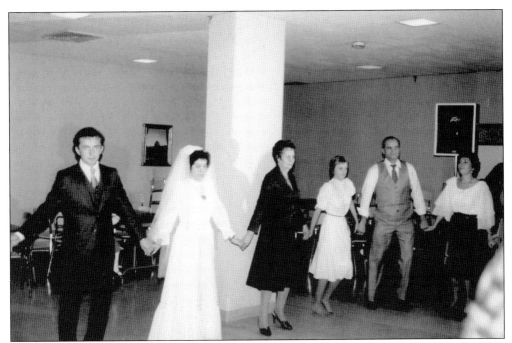

A wedding reception for Esad and Ajsa Suljic in 1983 was held in the social hall at the ICC. Wedding ceremonies are traditionally held in the prayer hall or lecture hall at the center. Here, from left to right, Esad Suljic; his bride, Ajsa; Marija Suljic; Jasna Suljic; Ibrahim Suljic; and an unidentified woman dance the kolo. (Courtesy of Ibrahim and Marija Suljic.)

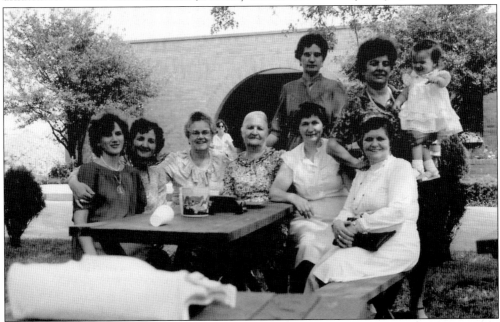

A group of Bosnian American women enjoy the sunshine in the courtyard behind the ICC in the 1980s. Seated at the picnic table, from left to right, are Mrs. Bektasevic, Hadija Bektasevic, Sefika Bojic, Raza Torlo, Zehra Bambur, and Semsa Besic. Standing behind them are Abida Zec and Gara Kljako, holding a baby. (Courtesy of Sabid and Semsa Besic.)

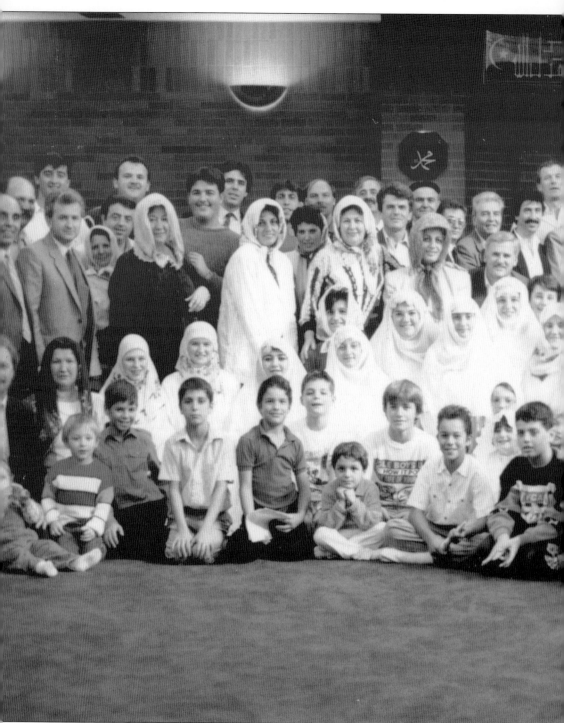

The Bosnian American community poses for a group photograph in the prayer hall at the ICC in 1988, soon after the prayer hall addition was built. The close-knit community has worked together since the ICC's inception in the 1970s, and the group still works together to organize

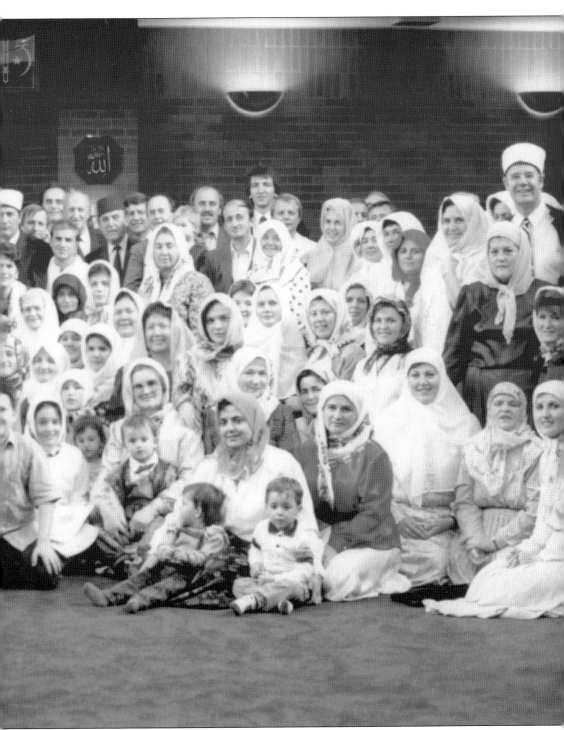

celebrations and fund-raisers, women's group events, and educational and national affairs. This practice has been passed down, encouraging the younger generations to take over and continue the community's traditions. (Courtesy of the Bosnian-American Cultural Association.)

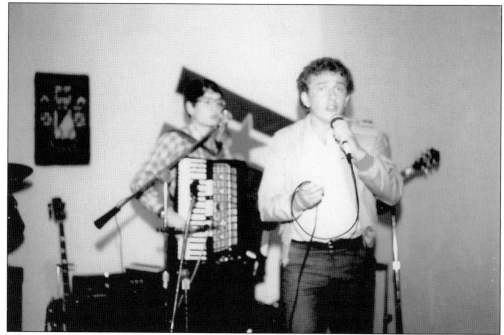

Esad Suljic, in the foreground, has always been known for his singing of Bosnian folk songs. Here he performs at the Jugoslovenski Klub, or Yugoslav Club, on Irving Park Road and Lincoln Avenue in Chicago in the 1980s. The club closed its doors after the Balkan war started. (Courtesy of Ibrahim and Marija Suljic.)

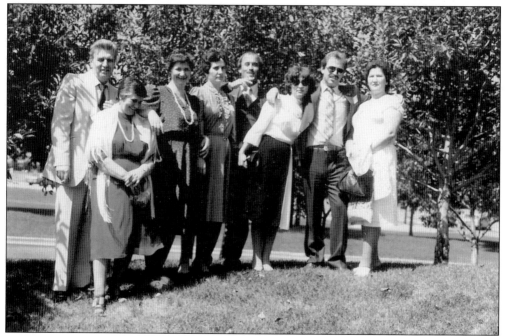

Friends among the community smile for a picture in the early 1980s. Standing in the group are, from left to right, Sabid and Semsa Besic, Zehra Zec, Abida and Zakir Zec, Nisveta and Ibrahim Buljina, and Latifa Spahic. (Courtesy of Sabid and Semsa Besic.)

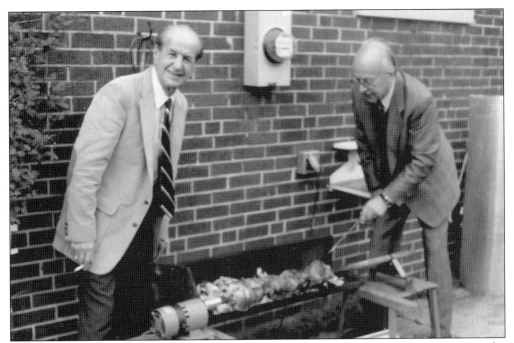

Hrusto Salihbegovic (left) and a friend tend to a chicken roast at Nurko Gazija's home in the 1980s. While traditional methods would require someone twisting the spit, motorized rotators have become the preferred way of roasting. (Courtesy of Nurko Gazija.)

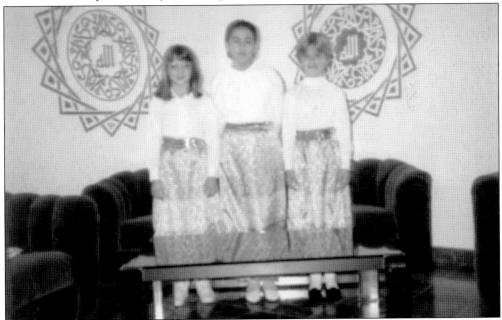

From left to right, Sanela Puskar, Amra Ovcina, and Jasmina Zec sport traditional *dimije*, a form of traditional skirtlike trousers imported to southeastern Europe by the Ottomans in the 15th century. The girls participated in a *mevlud*, the celebration of Prophet Muhammad's birthday, in 1987. The annual event brings the community together to honor the prophet through prayers, recitations, and song. (Courtesy of Muhamed and Ismeta Puskar.)

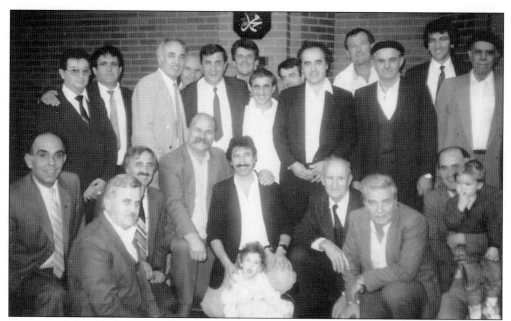

Men from the community pose for a group photograph in the early 1980s. From left to right are (first row) Fazlija Cubic, Ehrem Dedic, Tahir Zec, Saban Torlo Jr., Medzid Ibisi and his daughter Elma, Dzemal Kusturica, Sabid Besic, and Bakir Zec with his son Haris; (second row) Tahir Sabovic, unidentified, Osman Bihorac, Muhamed Trbic, Idris-ef Demirovic, Hasan Cubic, Becir Becovic, Idris Mujdragic, Huscin Becovic, Rasid Ovcina, Camil Perazic, Dr. Hasim Cosovic, and Mehmed Pekovic. (Courtesy of Sabid and Semsa Besic.)

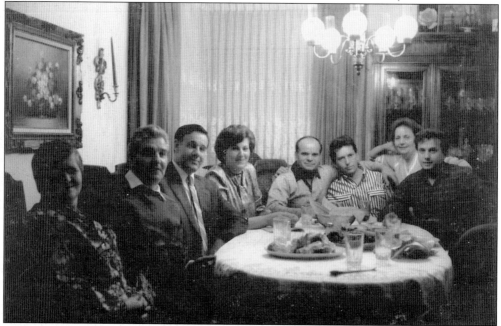

Dinner is served at the home of Ibrahim and Marija Suljic in Niles in the 1980s. Seated are, from left to right, Semsa and Sabid Besic; imam Ekrem Mujezinovic and his wife, Hafiza; Ibrahim Suljic; Safet Suljic; Marija Suljic; and Esad Suljic. (Courtesy of Ibrahim and Marija Suljic.)

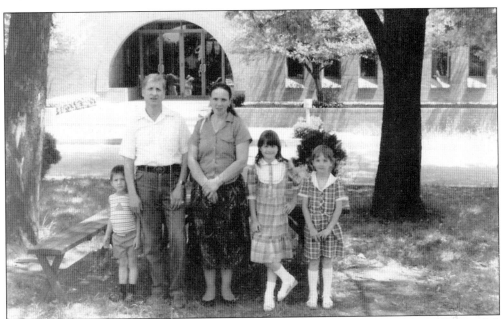

The Pasabeg family poses for a snapshot in the mid-1980s in the courtyard of the ICC; from left to right are Kerim, Ismet, Rabija, Sabina, and Lejla Pasabeg. (Courtesy of Rabija Pasabeg.)

Muharem Zulfic and Latifa Spahic take a picture during one of Zulfic's annual Fourth of July picnics at his house in Northbrook. (Courtesy of Mejra Becirovic.)

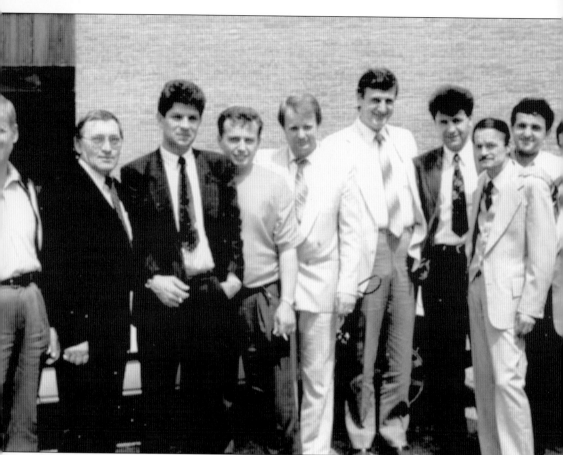

Bosnians are seen here gathered to welcome a delegation from Sandzak. Standing from left to right are Ismet Pasabeg, unidentified, Dr. Sulejman Ugljanin, Esad Suljic, Muhamed Puskar, Abduselam Koradzic, Rasim Ljajic, Ramiz Krvavac, Faruk Bektasevic, and Hasan Kajtezovic. (Courtesy of Muhamed and Ismeta Puskar.)

Four

THE BOSNIAN WAR

The death of Pres. Josip Broz Tito and the subsequent collapse of Yugoslavia in the 1980s led to war, splitting apart the former Yugoslavia into republics fighting for their independence in the first half of the 1990s. Thousands of people from all over the region died in the battles for control in the most violent ethnic strife since World War II.

Thousands also sought refuge outside the region, and numerous families and individuals made their way to the United States from their war-ravaged homeland. Because of the already established community, Chicago became the most popular destination for an estimated 40,000 Bosnian refugees, making it the largest wave of Bosnian immigrants ever to Chicagoland. Many found help and resources from various organizations and religious centers in the area.

An estimated 300,000 people lost their lives in the war, and countless more lost their homes, relatives, and friends. Those who chose to rebuild their lives in Chicago found a community that was only strengthened by their arrival. The Bosnian Americans of Chicagoland poured money, supplies, and resources into Bosnia-Herzegovina any chance they could get and offered emotional and economic support, places to live, and guidance for the newcomers to navigate their new homeland.

With their presence and involvement, Bosnian Americans have experienced a boost in and revitalization of cultural and religious affairs. They have revived the connection to Bosnia-Herzegovina for many members of the community, and these relative newcomers have reawakened and strengthened the Bosnian presence in Chicagoland. With their help and drive, new support systems have been built and new organizations have been created to foster discussions, rebuild their homeland, and encourage a cultural reconnect.

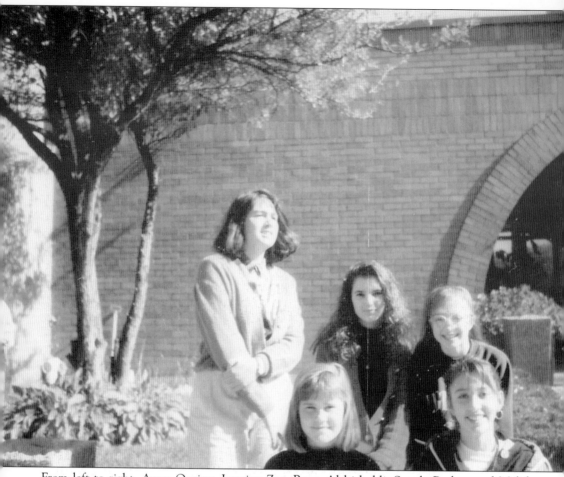

From left to right, Amra Ovcina, Jasmina Zec, Rana Alshishakli, Sanela Puskar, and Melida Ibisi attended Sunday school together in the early 1990s. (Courtesy of Muhamed and Ismeta Puskar.)

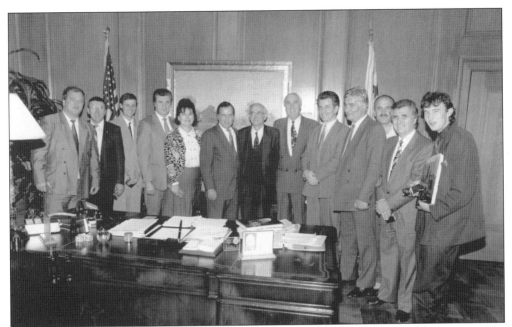

Bosnians from Chicago and Sarajevo gather at Mayor Richard Daley's office for a mayoral meeting with dignitaries from both cities in 1991. Standing from left to right are Omer Pobric, Hasim Hadzialagic, Senad Agic, Ilijas Zenkic, Zehra Deovic, Mayor Daley, Mayor Muhamed Kresevljakovic, alderman Richard Mell, Osman Brka, Zejerijah Dzezic, Zakir Zec, Hasan Avdich, and Muaz Borogovac. The Sarajevo dignitaries visited for about two weeks to promote the Stranka Demokratska Akcija (SDA) political party in Bosnia. (Courtesy of Hasan Avdich.)

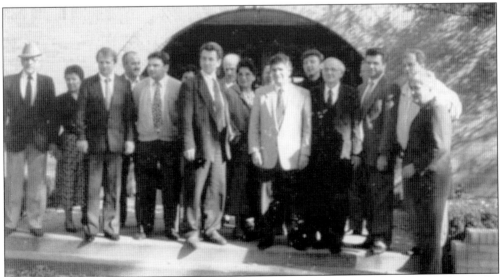

The Bosnian community in Chicago organized support for the SDA political party during the war in the 1990s. On the steps of the ICC are, from left to right, Saban Torlo Sr., Zejna Zec, Muhamed Puskar, Zakir Zec, Zihad Bajraktarevic, Osman Brka, Ismet Vilic, Zehra Deovic, Hasan Avdich, Muaz Borogovac, Sarajevo mayor Muhamed Kresevljakovic, Ilijas Zenkic, Omer Pobric, and Zekerijah Dzezic. (Courtesy of Muhamed and Ismeta Puskar.)

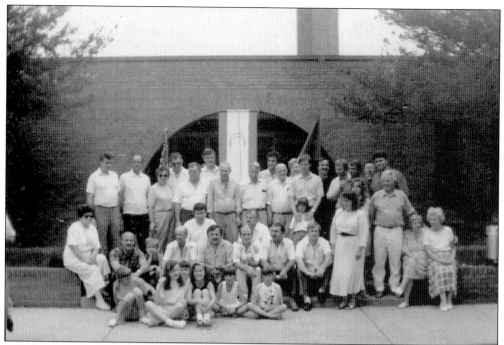

A group of Bosnians organized a Chicago chapter of the SDA in 1992 in support of the leading political party in Bosnia-Herzegovina. Here some of the organizers gather for a picture with family and friends. (Courtesy of the Bosnian-American Cultural Association.)

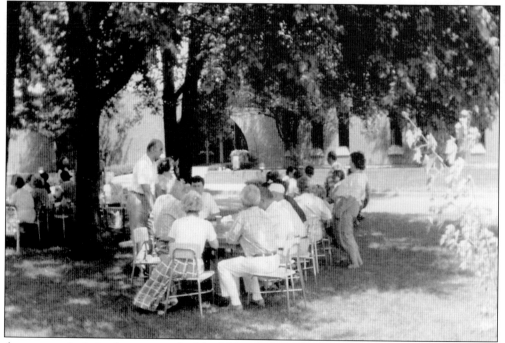

A summer picnic in the courtyard of the ICC is held to bring together organizers for events to raise money, support, and awareness for fellow Bosnians. (Courtesy of the Bosnian-American Cultural Association.)

Fund-raisers were held frequently to raise money for supplies for the SDA party in Bosnia during the war in Yugoslavia. From left to right, Safet Slimic, Omer Puskar, unidentified, Senad Agic, and SDA representative Osman Brka pose for a photograph in 1992 in the social hall at the ICC. (Courtesy of Omer and Fatima Puskar.)

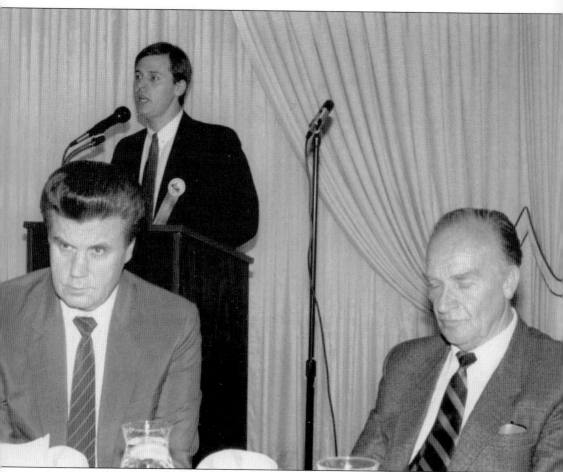

Ilijas Zenkic, left, and former Bosnian president Alija Izetbegovic, right, listen as imam Senad Agic delivers an address during a fund-raiser. Izetbegovic visited Chicago during the war in the Balkans to garner support for his SDA party. He spent about two weeks in the United States and Canada during that trip. (Courtesy of Senad Agic.)

Ilijas Zenkic, center, ran for Congress as a Republican against incumbent Dan Rostenkowski for the 5th District of Illinois on the northwest side in 1992. Here he stands with Husnija Suljic, left, and Alfred Tischler at a campaign event. (Courtesy of Husnija and Fata Suljic.)

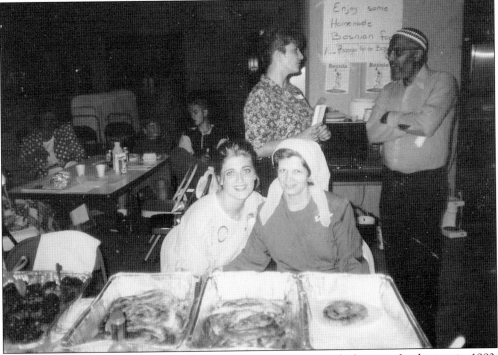

Zlatka Puskar and her aunt Fatima Puskar smile for a photograph during a fund-raiser in 1993. (Courtesy of Omer and Fatima Puskar.)

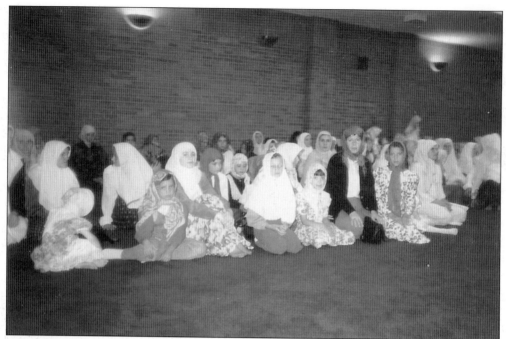

Bosnian American women gather for prayer at the ICC in the early 1990s. (Courtesy of Husnija and Fata Suljic.)

Over the last century, Bosnian American women have been a driving force behind cultural and fund-raising events. Here, from left to right, Fata Suljic, Nadira Agic, Nefa Torlo, Zejna Zec, Zehra Bambur, Hidajeta Alshishakli, and Ismeta Puskar gather for a quick photograph while packing clothes to send to Bosnia. (Courtesy of Muhamed and Ismeta Puskar.)

People hailing from all over the Balkans help box supplies for the ill and injured during the war. Here Muharem Cantic in the foreground, with relatives, helps Sabid Besic, back left, Rasid Ovcina, and Hasim Cosovic pack supplies to send to Bosnia. (Courtesy of Sabid and Semsa Besic.)

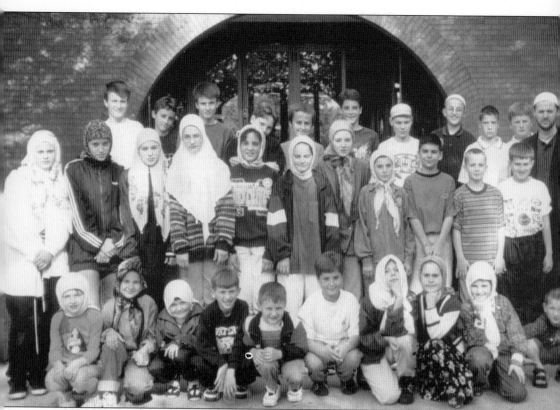

A Sunday school class photograph features about 30 Bosnian American children, both newcomers and American-born, in 1995. The number of Bosnians, both old and young, grew substantially in Chicagoland during and after the war as new immigrants moved to the area. (Courtesy of the Bosnian-American Cultural Association.)

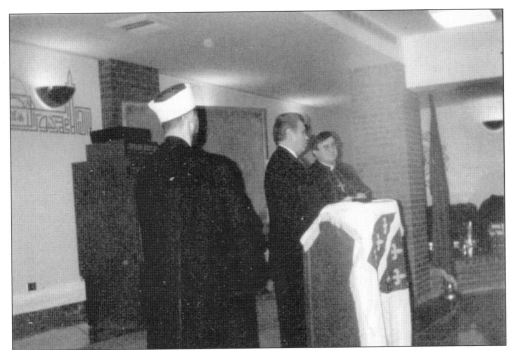

Ilijas Zenkic introduces Cardinal Vinko Puljic, the archbishop of Sarajevo, in October 1998, as imam Senad Agic of the ICC stands by. During his visit he helped raise money for refugee children in Chicago. (Courtesy of the Bosnian-American Cultural Association.)

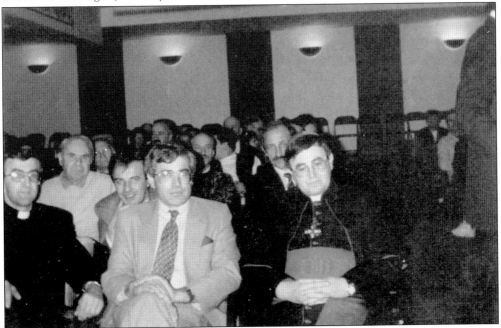

Cardinal Vinko Puljic listens to an address in the lecture hall of the ICC in 1998. His visit was especially notable as leaders and members of two different faiths, from the same land, came together for the same purpose. To his right is Sven Alkalaj, Bosnian ambassador to the United States. (Courtesy of the Bosnian-American Cultural Association.)

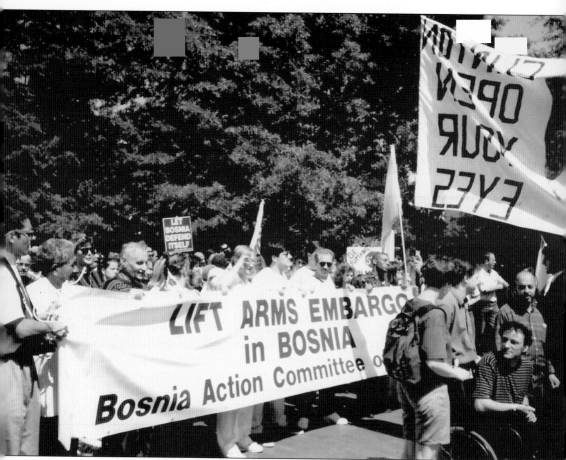

An estimated 100,000 Bosnians and other protesters came to Washington, D.C., in May 1993 to call on the American government to lift the arms embargo against Bosnia. Many Bosnian Americans from the Chicago area traveled by bus to participate in the demonstration. (Courtesy of Mejra Becirovic.)

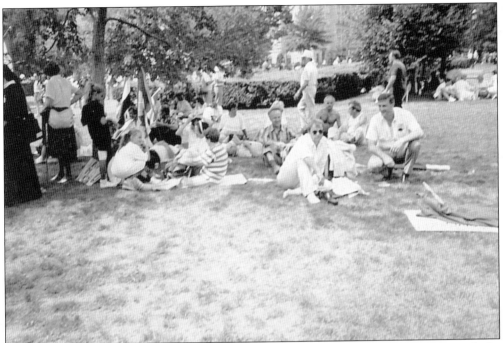

Demonstrators take a break during the protest in Washington, D.C. People of many faiths converged on the Capitol to support the effort in Bosnia. (Courtesy of Muhamed and Ismeta Puskar.)

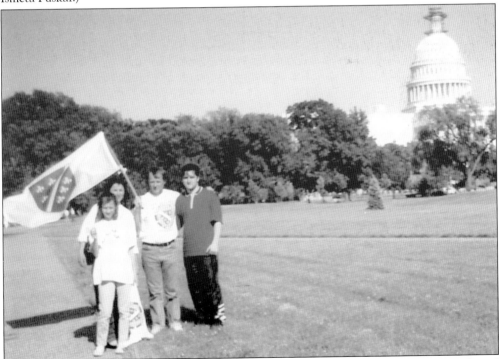

The author, left, gathers with her mother, Ismeta; her father, Muhamed; and her cousin Senad Puskar, as the Capitol stands in the background. (Courtesy of Muhamed and Ismeta Puskar.)

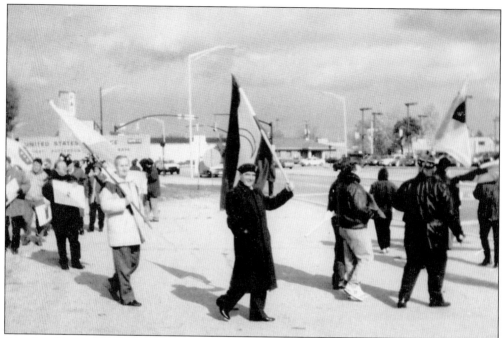

Another demonstration in support of Bosnia occurred during the Dayton Peace Accords in Dayton, Ohio, in November 1995. Some members of the Chicago community traveled to Dayton to witness the events and make known the support for Bosnia in the United States. (Courtesy of the Bosnian-American Cultural Association.)

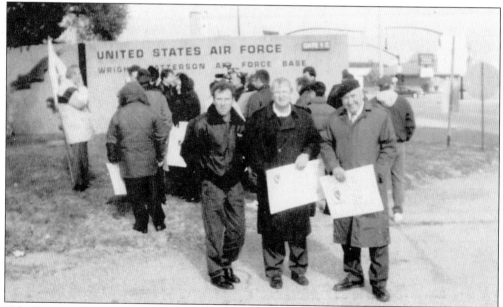

Nihad Softic (left), Ekrem Bambur (center), and an unidentified person pose in front of Wright-Patterson Air Force Base where the Dayton Peace Accords took place in 1995. The negotiations, which brought an official end to the war in the Balkans, convened leaders from Croatia, Serbia, and Bosnia and Herzegovina as well as from the United States, which mediated the event. (Courtesy of the Bosnian-American Cultural Association.)

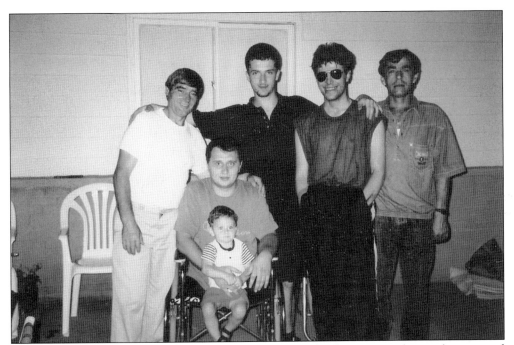

Many injured soldiers came to the United States for medical treatment during the war, and Chicago-area Bosnian Americans, among those of other communities in the United States, hosted them and offered support. Here, from left to right, Omer Puskar, Edhem ?, Mirza Seta, Bahrudin Mujkic, and an unidentified man pose for a picture outside Puskar's home in Hoffman Estates. (Courtesy of Omer and Fatima Puskar.)

Nihad Softic, right, with his son, Ismir, above center, came to the United States in 1995 to escape the war. Here they enjoy the company of Omer Puskar, left, and Samir Mustafic, below center, at the home of Halil Puskar in Des Plaines. (Courtesy of Omer and Fatima Puskar.)

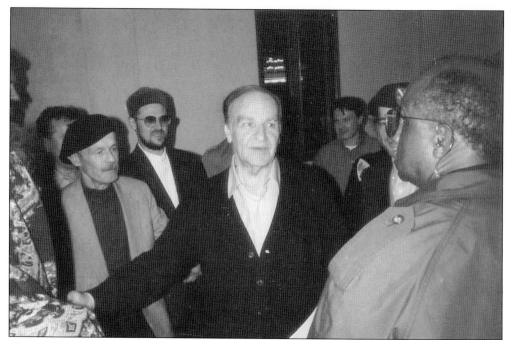

Former Bosnian president Alija Izetbegovic, center, in the United States for the Dayton Peace Accords, visited a group of Bosnians who came to Ohio to rally support for Bosnia. He is joined by Ramiz Krvavac, left, and imam Senad Agic. (Courtesy of the Bosnian-American Cultural Association.)

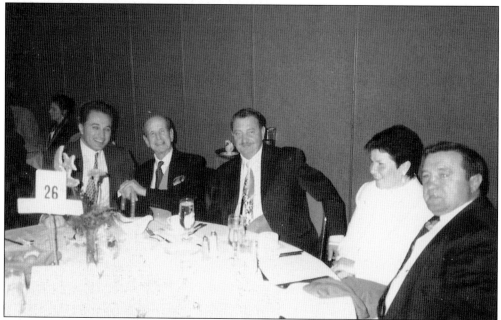

A fund-raiser is held at a Chicago-area banquet hall in November 1994, where Asim Puskar, center, gathers with friends and family for dinner. To his right are Hrusto Salihbegovic and Asim Cemalovic, the Bosnian consul in New York. To his left are Hazema and Kasim Puskar. (Courtesy of Nurko Gazija.)

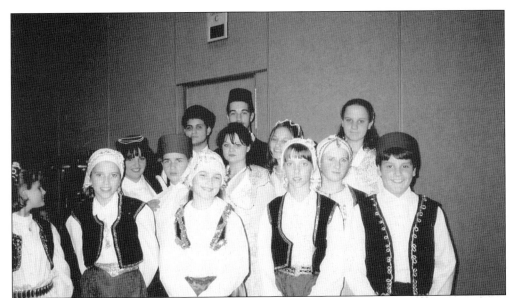

A fashion show featuring Bosnian folk costume was part of the fund-raiser's events in November 1994. Standing from left to right are (first row) Amra Agic, Deena Suljic, Semka Puskar, Mersa Suljic, Melisa Dautovic, and Enes Ovcina; (second row) Jasmina Redzovic, Adem Redzovic, unidentified, the author, and Amna Ovcina; (third row) Amir Ovcina and Ibro Torlo. (Courtesy of Muhamed and Ismeta Puskar.)

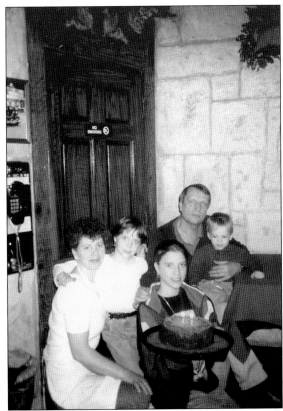

The Suljic family poses at the Lincoln Square restaurant they owned and ran in the 1990s. Here, from left to right, Fata, Maida, Deena, Husnija, and Husko Suljic celebrate Husko's birthday in 1997. (Courtesy of Husnija and Fata Suljic.)

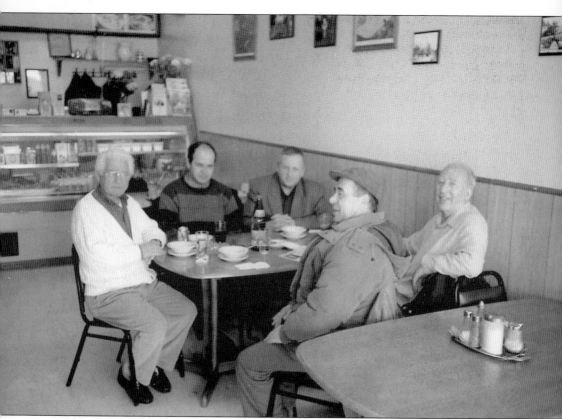

Bosnian Americans enjoy coffee at Balkan Restaurant in Chicago's Lincoln Square neighborhood in 2003. Clockwise from left are Nurko Gazija, Bosnian politician Adil Osmanovic, former Bosnian general Rasim Delic, Becir Tanovic, and unidentified. (Courtesy of Nurko Gazija.)

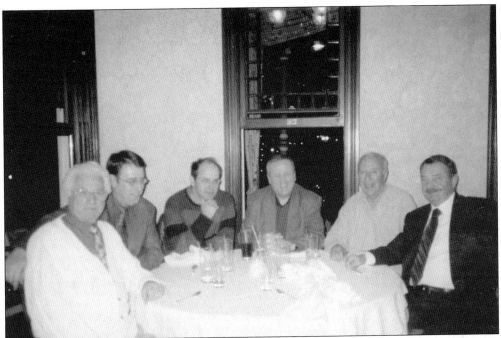

Nurko Gazija and, from left to right, Fuad Puskar, Adil Osmanovic, Rasim Delic, Becir Tanovic, and Asim Puskar enjoy dinner at a restaurant in Lake Geneva, Wisconsin, during the Bosnian delegation's visit to the United States in 2003. (Courtesy of Nurko Gazija.)

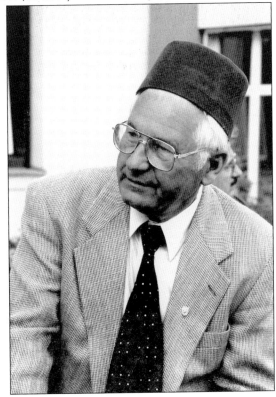

Nurko Gazija has been a longtime advocate of Bosnian American affairs and causes since he first arrived to Chicago in 1950. (Courtesy of Nurko Gazija.)

A traditional lamb roast takes place in the early 1980s in Nurko Gazija's backyard, where Bosnian American friends and neighbors gather regularly. The lamb roast is one of many Bosnian traditions that have carried over from the homeland. (Courtesy of Nurko Gazija.)

Five

KEEPING
TRADITIONS ALIVE

The Bosnian American community has changed and will continue to change over the years, but its heritage remains the vital constant. Traditions in music and dance, folk costume, religious affairs and holidays, language, cuisine, and so on will continue to bring the community together and remind it of its background and history.

These traditions speak for themselves. Their importance in daily Bosnian American life has driven members of the community to keep them thriving, passing them on from generation to generation. They are evident in community affairs, such as potluck dinners, where traditional Bosnian dishes are predominant; weddings, where Bosnian customs are abundant; and religious occasions, where Bosnian influences, such as song and costume, are evident.

Bosnian American organizations also keep traditions vibrant. Religious associations have long brought the community together, being the first place immigrants have gone to seek friendship, company, and community. From those like Dzemijetul Hajrije to the ICC, the religious center, as in many ethnic and immigrant circles, has fostered cultural affairs and traditions. These religious centers would sprout community organizations, like women's groups and benevolent concerns, and even bands and sports teams.

Most importantly, these organizations have fostered friendships, childhood or lifelong, driven by proximity in the Chicagoland area or their hometown in Bosnia, common interest, or simply similar life stories. Whatever drives these friendships and associations, the traditions of Bosnian American culture remain a cornerstone.

One would be hard-pressed not to find food at a Bosnian American gathering. Here Marija Suljic and Fata Suljic tend to the grill in Marija's backyard in the early 1980s. Traditional Bosnian food is one of the most important elements of any gathering, and it brings members of the community and friends together. (Courtesy of Ibrahim and Marija Suljic.)

In an earlier photograph, Ibrahim Suljic cooks some big steaks at a backyard picnic in the 1970s, with a friend and his daughter, Jasna, in the background. (Courtesy of Ibrahim and Marija Suljic.)

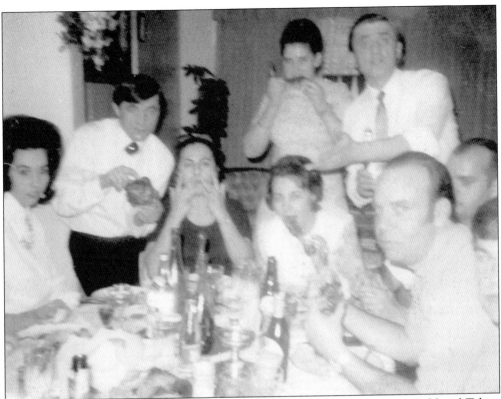

A candid photograph shows the prevalence of Bosnian cuisine at a dinner at Halil and Tahira Puskar's house in March 1970. (Courtesy of Ibrahim and Marija Suljic.)

Birthday parties will always bring a group of friends together, as one did for Fadil Suljic's birthday in the 1970s. While cake and soda are the main attraction, cuts of smoked meat and pickles sit waiting to be eaten in the foreground. (Courtesy of Ibrahim and Marija Suljic.)

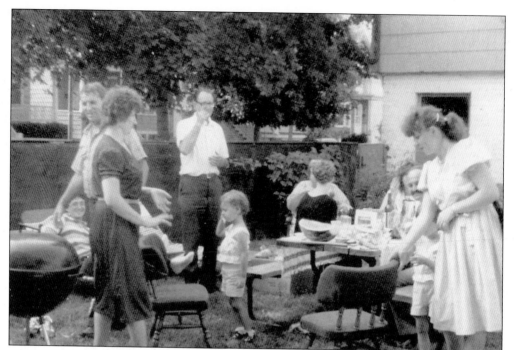

Although it is likely influenced by American culture, the backyard picnic has been adopted by Bosnians as their own. From left to right standing are Husnija Suljic, Mejra Becirovic, Muharem Zulfic, Mersa Suljic, and Fata Suljic, enjoying a backyard gathering in the mid-1980s. (Courtesy of Husnija and Fata Suljic.)

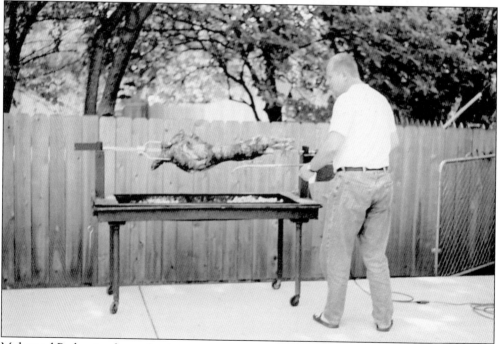

Muhamed Puskar tends to a lamb roast at a summer party in July 2002. (Courtesy of Muhamed and Ismeta Puskar.)

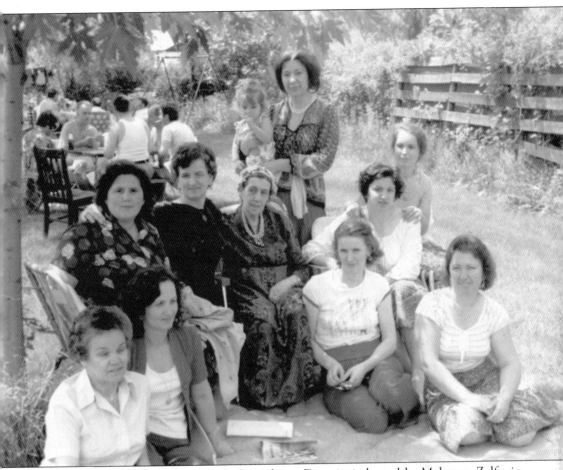

Bosnian American women enjoy an Independence Day picnic hosted by Muharem Zulfic in the 1970s. From left to right are Sefika Bojic, Hadija Bektasevic, unidentified, Rasema Dedic, Rasema Dedic's mother, Mensura Lejlic, Munira Kreso, Fatima Dedic, Mukerema Senolan, and Zejna Zec. (Courtesy of Mensura Lejlic.)

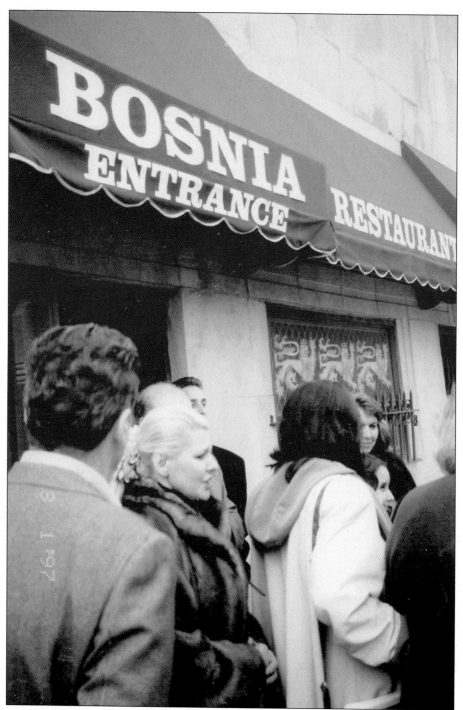

Bosnian Americans gather outside the Bosnia Restaurant entrance for a Bosnian Independence Day celebration, held March 1 of every year. Bosnian establishments like this restaurant (now closed) are popular places to find friends, Bosnian fare, and camaraderie. Most Bosnian-owned businesses are located along the Lincoln Avenue corridor in Chicago, near Lincoln Square, but they can be found throughout the Chicago area. (Courtesy of Husnija and Fata Suljic.)

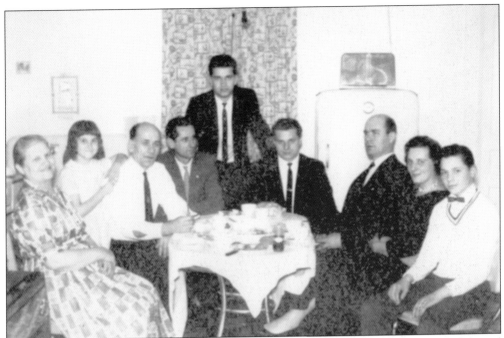

Turkish-style coffee can be found in just about any Bosnian American home. Friends and family in this picture gather at the Torlo home in Chicago in the 1950s. From left to right are Raza Torlo, Enisa Hadzic, Saban Torlo Sr., Hamo Hadzic, Saban Torlo Jr., Mustafa Celik, Abas Salkanovic, Greta Salkanovic, and the Salkanovics' son gather for coffee. (Courtesy of Saban and Nefa Torlo.)

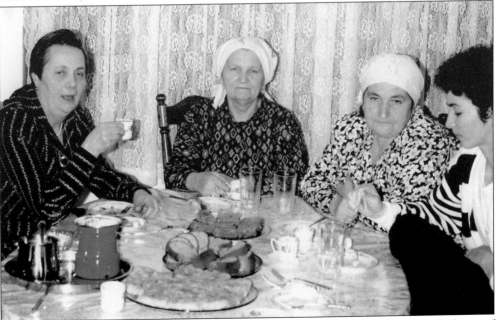

From left to right, Marija Suljic, Secima Suljic, Safija Suljic, and Ismeta Puskar sit at the home of Fata and Husnija Suljic for postdinner coffee, an essential for any Bosnian gathering. (Courtesy of Fata and Husnija Suljic.)

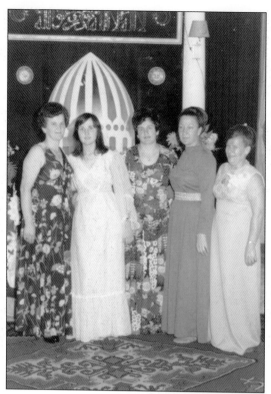

Weddings are full of Bosnian tradition, from the location of the ceremony to customs and rituals before and during the ceremony. Here Bosnian American women and friends pose for a snapshot with a bride in the 1960s at the Muslim Religious and Cultural Home. (Courtesy of Mensura Lejlic.)

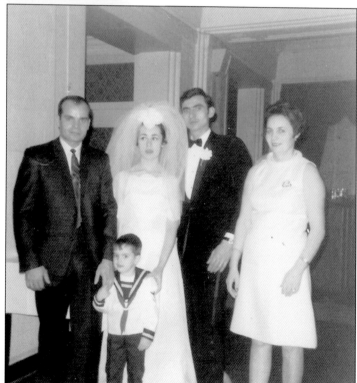

The wedding of Edham Burzic, in tuxedo, took place in March 1969. (Courtesy of Ibrahim and Marija Suljic.)

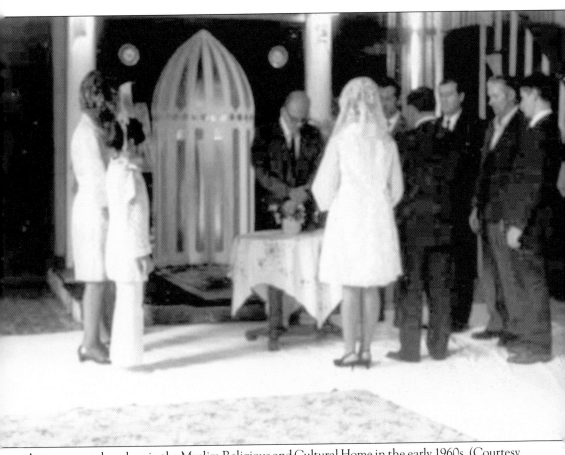

A ceremony takes place in the Muslim Religious and Cultural Home in the early 1960s. (Courtesy of Rabija Pasabeg.)

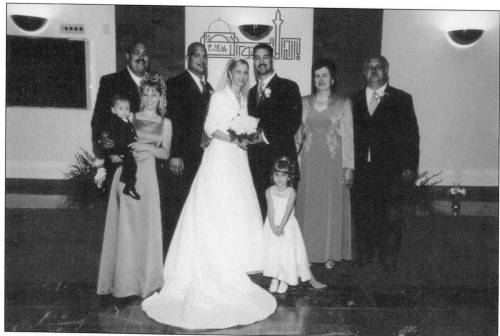

A more recent wedding, that of Sabina and Ibro Torlo, took place in September 2004. Here the groom's family poses for a picture in the lecture hall of the ICC in Northbrook. (Courtesy of Saban and Nefa Torlo.)

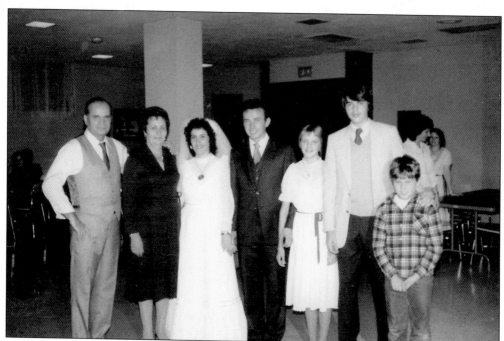

The wedding reception of Ajsa and Esad Suljic was held in the social hall of the ICC in the 1980s. (Courtesy of Ibrahim and Marija Suljic.)

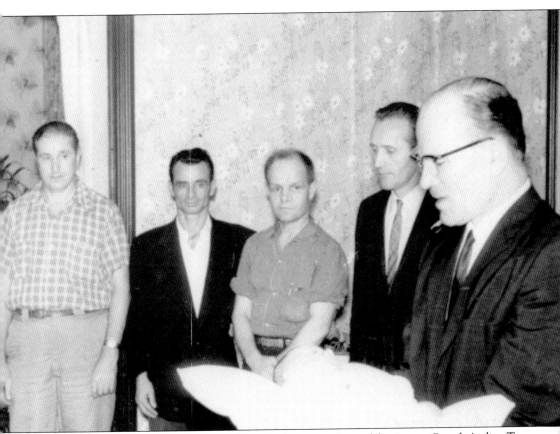

The naming ceremony for newborn Bakir Viteskic is performed by imam Camil Avdic. To his right are the father, Husein Viteskic, Seid Karic, Muradif Jesarevic, and Remzo Selimovic. (Courtesy of Hajra Karic.)

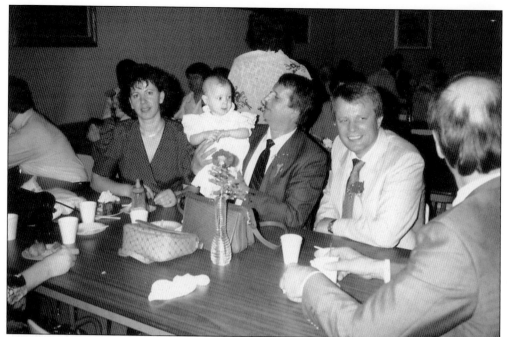

A religious celebration takes place in the social hall of the ICC in 1991. From left to right are Fata, Maida, and Husnija Suljic, and Muhamed Puskar. Religious celebrations are one of the most unifying events among the Bosnian American community, as they are known to be in Bosnia. The tradition of big celebrations is as strong as ever. (Courtesy of Husnija and Fata Suljic.)

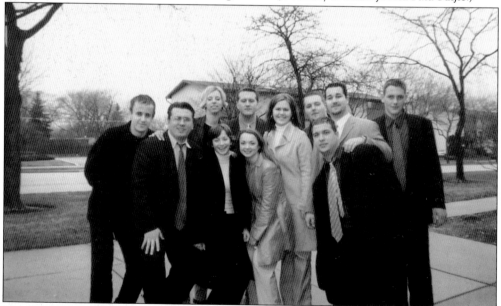

Friends enjoy one another's company during an Eid holiday as they head to a relatively new tradition of going out for breakfast, since Eid starts early in the morning. From left to right are Jasmin Zec, Merim Becirovic, Mersa Suljic, Samira Puskar, Sanela Puskar, Elmir Becirovic, Jasmina Zec, Dzerad Becirovic, Omer Torlo, Ibro Torlo, and Muamer Klaric. (Courtesy of Sanela Puskar.)

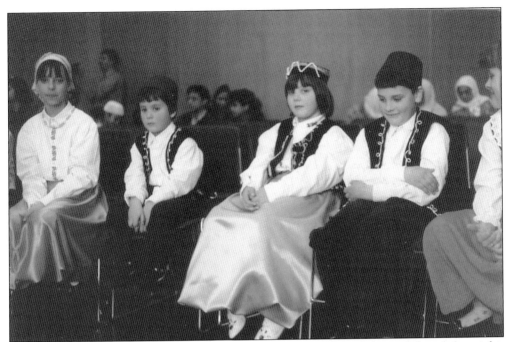

Bosnian costume is a popular and well-highlighted tradition. Mersa Suljic and, from left to right, Adnan, Enesa, and Enes Ovcina, and Amra Agic show off the traditional dimije, decorated vests, and fez caps at a cultural event in the 1990s. (Courtesy of Husnija and Fata Suljic.)

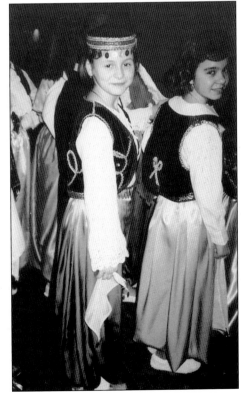

Fatima Agic poses for a photograph in traditional folk costume during a Bosnian American event in 2004. She is seen wearing a decorated cap, a black velvet vest with gold trim, and dimije. (Courtesy of Muhamed and Ismeta Puskar.)

115

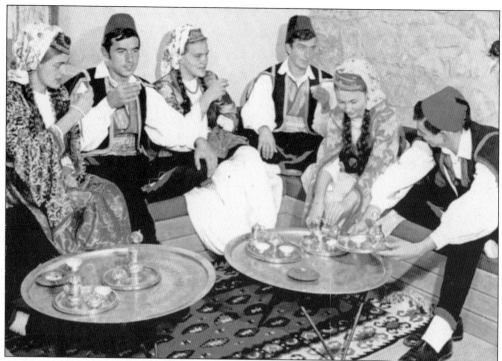

A postcard from the 1960s highlights traditional costume worn by Bosnians, seen drinking traditional Turkish-style coffee from little cups called *fildzans* in time-honored copper ware. (Courtesy of Nurko Gazija.)

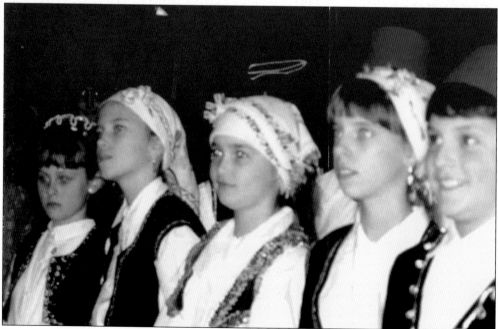

The traditional costumes continue in the Chicago area. Participants of a folk costume fashion show look on at a dinner in 1994. (Courtesy of Muhamed and Ismeta Puskar.)

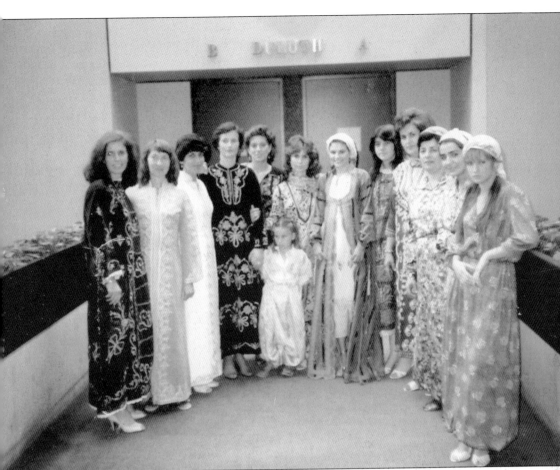

Nedime Tanovic and, from left to right, Inga Sarich, unidentified, Azra Ceric, unidentified, Mukerim Senolan, Azra Bojic, Suvada Kljako, Nefa Torlo, Razija Kljako, Mahira Zec, and Nasiha Bambur pose in traditional Bosnian costume at an Islamic convention in Detroit in 1983.

School is an undeniable part of Bosnian American life and a way to integrate into American society, for both students and their parents. Over the years, as it became more of a possibility, pursuing a diploma and a college education has become an important goal for Bosnian Americans. Here Sabid and Semsa Besic pose with their high school graduate, Saima. Saima finished high school at Roosevelt High School in 1975 and obtained her college degree from Wilbur Wright College in Chicago. (Courtesy of Sabid and Semsa Besic.)

Family is and has been the most important element of Bosnian American life. Caring for children and, later on in life, one's parents is a crucial aspect of a Bosnian American family, from which are instilled culture, customs, and traditions. Here Saban Jr. poses with his parents, Raza and Saban Sr., in 1959. (Courtesy of Saban and Nefa Torlo.)

Owning a home is definitely part of the American dream and is one for many Bosnian Americans. Sabid and Semsa Besic lived in their Spaulding Avenue home in Chicago before moving to Skokie. (Courtesy of Sabid and Semsa Besic.)

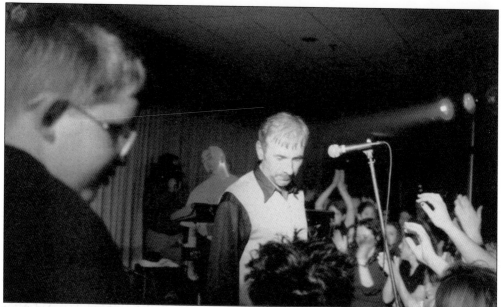

Music, as in other ethnic groups, is a vital part of Bosnian American life. From Bosnian folk to Bosnian rock, Bosnian music continues to be popular among expatriates and their families. Dino Merlin, a popular Bosnian music star, performed at a Chicago-area banquet hall in 1997 to a huge crowd of fans. Bosnian musicians come to Chicago regularly to perform to area Bosnian Americans.

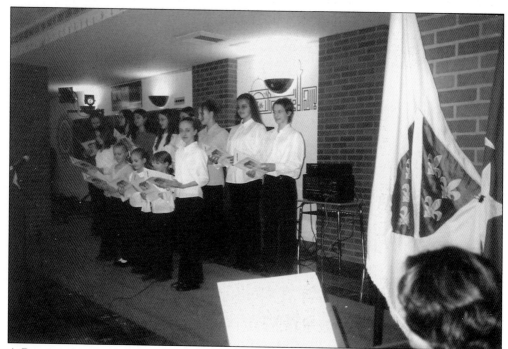

A Bosnian American choir sings at a cultural event at the ICC. Such organizations lost speed between generations until the most recent wave of Bosnians arrived in the 1990s, when Bosnian culture saw resurgence. (Courtesy of Fata and Husnija Suljic.)

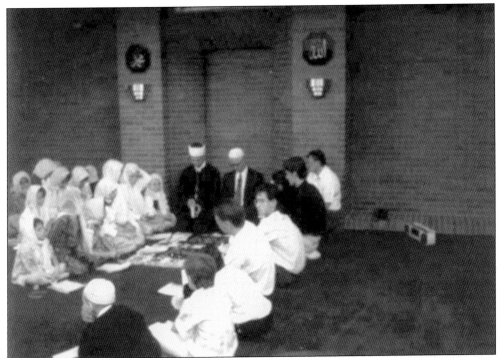

The mevlud is another event with traditional song. Children's recitals and presentations are a regular highlight at these religious events. (Courtesy of Muhamed and Ismeta Puskar.)

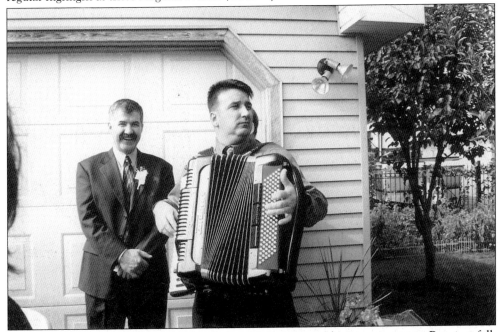

And the accordion, more than any other, is the most popular instrument in Bosnian folk tradition. Here Sejo Habibovic performs at his brother Muki's preceremony reception in October 2004. The accordion is a guaranteed sight at any Bosnian musical event or celebration, as it is the basis for folk music. (Courtesy of Husnija and Fata Suljic.)

Mejra Becirovic (left) and Latifa Spahic enjoy new blooms. Tending flower and vegetable gardens is a favorite hobby and popular tradition, as well as a source of pride, among Bosnian Americans. (Courtesy of Mejra Becirovic.)

Meho Kujundzic poses by the Lincoln Park gardens in the 1950s. Traditionally, when possible, time away from work and with family is spent outdoors, in natural environments. (Courtesy of Meho and Zineta Kujundzic.)

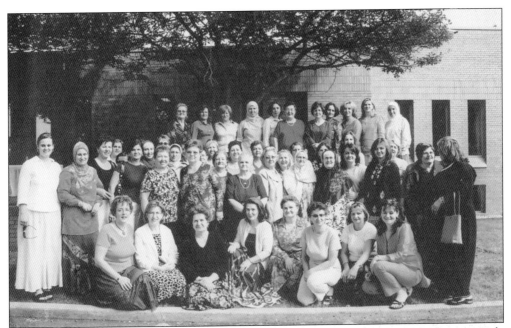

Members of a Bosnian American women's group join together for a recent picture outside the ICC. The group has grown steadily, has organized numerous events and help for various causes, and has been the source of many traditions in the community. (Courtesy of Sabid and Semsa Besic.)

Latifa Spahic, left, and Rasema Dedic show off a cake featuring the ICC in the 1980s. The two are longtime members of the Bosnian American community. (Courtesy of Rasema Dedic.)

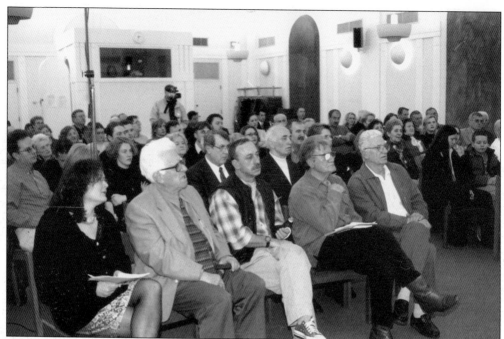

Literary tradition has spread from Bosnia's borders onward to the shores of Chicago, where lectures and discussions have sprouted among the community. Chicago is also home to Bosnian American writer Aleksandar Hemon, an accomplished novelist. (Courtesy of Selena Seferovic.)

Brothers Himzo Becirovic (left) and Mehmed Becirovic play a game of cards in the 1980s. Games like *zendar* are passed down through generations and offer a fun way to pass the time with friends and family. (Courtesy of Mejra Becirovic.)

Soccer is the preferred sport of Bosnians both in Chicago and abroad. Local teams like the one pictured above have sprouted around the city and have kept soccer a popular sport event and tradition among Bosnian Americans. (Courtesy of Fata and Husnija Suljic.)

The SC BiH soccer team participates in the Chicago-area National Soccer League's major division. The team pictured here won the 2007 league championship. Players on the team are mostly postcollege soccer players who play regularly at the Odeum Sports Center in Villa Park.

BIBLIOGRAPHY

A Centennial of Bosniaks in America. Chicago: the Bosnian-American Cultural Association and the Islamic Association of Bosniaks in North America, 2006.

Crampton, R. J. *Eastern Europe in the Twentieth Century*. 2nd ed. New York: Routledge, 1997.

Donia, Robert J., and John V. A. Fine Jr. *Bosnia and Herzegovina*. New York: Columbia University Press, 1994.

Glenny, Misha. *The Fall of Yugoslavia*. New York: Penguin, 1996.

Grossman, James, Ann Durkin Keating, and Janice L. Reiff. *The Encyclopedia of Chicago*. Chicago: University of Chicago Press and Newberry Library, 2004.

Gutman, Roy, and David Rieff. *Crimes of War: What the Public Should Know*. London: W. W. Norton and Company, 1999.

Miller, Olivia. "Bosnian Americans." In *Gale Encyclopedia of Multicultural America*. Detroit: Gale Group, 2000.

ACROSS AMERICA, PEOPLE ARE DISCOVERING SOMETHING WONDERFUL. THEIR HERITAGE.

Arcadia Publishing is the leading local history publisher in the United States. With more than 3,000 titles in print and hundreds of new titles released every year, Arcadia has extensive specialized experience chronicling the history of communities and celebrating America's hidden stories, bringing to life the people, places, and events from the past. To discover the history of other communities across the nation, please visit:

www.arcadiapublishing.com

Customized search tools allow you to find regional history books about the town where you grew up, the cities where your friends and family live, the town where your parents met, or even that retirement spot you've been dreaming about.